STEALING HISTORY

STEALING HISTORY

Art Theft, Looting, and Other Crimes Against Our Cultural Heritage

Colleen Margaret Clarke and Eli Jacob Szydlo

ROWMAN & LITTLEFIELD
Lanham • Boulder • New York • London

Published by Rowman & Littlefield
A wholly owned subsidiary of The Rowman & Littlefield Publishing Group,
Inc.
4501 Forbes Boulevard, Suite 200, Lanham, Maryland 20706
www.rowman.com

Unit A, Whitacre Mews, 26-34 Stannary Street, London SE11 4AB

British Library Cataloguing in Publication Information Available

Names: Clarke, Colleen Margaret, 1955– author. | Szydlo, Eli Jacob, author.
Title: Stealing history : a deeper understanding to art and cultural crimes / Colleen Margaret
 Clarke and Eli Jacob Szydlo.
Lanham, Maryland : Rowman & Littlefield, 2017. | Includes bibliographical references and index.
Identifiers: LCCN 2016041761 | ISBN 9781442260795 (cloth : alk. paper)
Subjects: LCSH: Art thefts. | Art—Forgeries. | Art—Mutilation, defacement, etc. | Cultural prop-
 erty—Protection.
Classification: LCC N8795 .C59 2017 | DDC 364.16/287—dc23 LC record available at https://
 lccn.loc.gov/2016041761

∞ ™ The paper used in this publication meets the minimum requirements of
American National Standard for Information Sciences Permanence of Paper
for Printed Library Materials, ANSI/NISO Z39.48-1992.

Printed in the United States of America

CONTENTS

INTRODUCTION

While relaxing and watching television or movies, most of us have seen shows like *White Collar* or movies such as *The Thomas Crown Affair* or *The Italian Job* and *To Catch a Thief.* This entertainment shows the classical archetype of the romanticized thief, the modern anti-hero, or the character of the bored art lover with too much time and money on his or her hands. These characters steal artwork as a representation of their love of art, the thrill of the chase, or simply to teach a lesson to the upscale museum curator.

These characters wear the finest suits, have perfectly combed hair, and know everything there is to know about the art, history, and artists whose work they are stealing. Their thefts are conducted carefully and planned to a T, with a little flair thrown in just to add insult to injury. This is usually directed toward the museum or private owner from whom they are stealing. The artwork is always treated carefully, never harmed, and often copied and described by the thief in articulate and loving detail. Due to the disingenuous portrayal of art crime in the entertainment industry, the general public is often misled on the subject of art crimes. However, by comparison to other crimes, why shouldn't art crime be presented in the context of amusement in the entertainment industry?

To the majority of the public, art is not important when compared to terrorism, drug abuse, and crimes directed at people, such as murder, rape, or kidnappings. Violent crime is far more prevalent and holds a higher priority in our society. Generally, people erroneously believe

that art crimes and cultural crimes do not actually damage anyone in a direct way.

So why is art important? Art is an emotional connection to our cultural history and the artist's interpretation of specific events that created that same history. Art complements the literature and descriptions of events that are found in history. This creates a contrast from the classroom lecture by offering a permanent association to a primary source of events through the eyes of the artists living at that time. Fred S. Kleiner, in *Gardners Art through the Ages*, states that "people cannot see or touch history's vanished human events, but a visible, tangible artwork is a kind of persisting event." This book is meant to offer the reader an in-depth overview of the subject matter of art and cultural crimes, and the policing thereof, primarily within the United States.

The image of art crime that Hollywood provides does not depict the disturbing emotions viewers experience when they view the empty frames displayed on the walls of the Isabella Stewart Gardner Museum in Boston, Massachusetts. Another infamous illustration of cultural carnage is the missing artwork from the destruction the Nazis wrought against countless cultures during World War II. The sad reality is that portions of the art stolen by the Nazi Regime have never been recovered, and are presumed destroyed.

The cultural destruction and neglect that is prevalent in American society is another issue that is closely associated with art crimes. The destruction and smuggling of Native American artifacts from North America is a loss of history that will never be replaced. The African American population is recognized for its accomplishments, and the events recorded as the Harlem Renaissance, yet so few Americans have heard of the movement. This begs the question, how do we in the United States regard our own culture and art works? Why is there a lack of recognition toward Mexican American, Asian American, and Native American artists, let alone countless other cultures that have contributed to the cultural identity of the United States?

Authors studying the field of art crime are writing about the dire and disturbing rate at which the illegal market has grown in popularity over the last half century. This is not just solely a historical issue because the advancement of modern technology and security has not kept pace. Technology, as well, has not allowed for close and personal inspection while maintaining the security and safety of the items. The museums

maintain a difficult balance: they have to offer easy public access while maintaining the proper protection and security for the artifacts stored within. In many cases the financial backing does not allow for advanced types of security, and it is often overlooked in order to create a memorable and inviting gallery.

With hundreds of years of history represented by these exhibited and stored artifacts—which are constantly on display wherever you go—countries in Europe take the issue of art crime very seriously. Artists and art historians, many from the United States, flock to Europe in order to further study these works of art. In comparison many American cities lack a great deal of the cultural identity that is present within Europe. Art crime is a type of class warfare; the theft of highly priced and well-known artwork garners little to no sympathy from those of the middle to lower classes who ask, "How does that affect me?"

The United States is the largest market for both legal and illicit artworks in the world, yet the FBI employs a minimal number of agents to investigate the most detrimental art crimes. On the other hand, Italy, a country with an extremely high rate of art crime, and a longstanding cultural history, employs hundreds of investigators primarily for art crimes. The cultural difference and reverence to art can be viewed and better understood when one considers how seriously that country takes the crimes of art and culture. Many European countries, having thousands of years of history, appear to value the arts more than the United States, a significantly younger country and culture by comparison.

Many of the artifacts that are brought illegally into the United States and European countries are stolen from less-protected sites where they are carefully and gently being excavated. Many poorer cultures do not have the same respect for their cultural history and monuments, considering them more as a means of attaining money. Unfortunately, this will result in the mishandling and destruction of many invaluable works of history that are essential for a greater cultural understanding. Many of these items will eventually make their way into legitimate markets, mainly through the use of a faked historical record of ownership and sale.

Art and cultural crime is not simply focused on museums or private displays; the loss of art directly affects our cultural identity and history. These factors demand that we direct more preventative and investiga-

tive attention from law enforcement and security from the United States to meet international standards.

I

MEDIA'S PORTRAYAL OF ART CRIME

The United States is famous for its entertainment industry—Hollywood, television, music, advertising, and video games—which is linked to technology and spread across the world. Characters portrayed in the entertainment industry become household names, as familiar to someone in Singapore as to a person in New York City. While it can be said the entertainment industry has a definite impact on culture worldwide, it is difficult to estimate the far-reaching impact this industry has on society's beliefs about art thieves. How far do characters portrayed in the entertainment industry invade our psyche? The question remains: does society recognize the seriousness of art theft and subsequent theft of culture to our nation and to cultures worldwide?

Let's face it, for entertainment value there is nothing better than a movie that takes you on a wild ride of mystery and cunning with the theft of multi-million-dollar art or jewels where the protagonist beats all odds and walks away wealthy and smug. This is often the case when mass media make television shows and movies that glorify art thieves.

The entertainment industry, in many cases, portrays law enforcement as uncouth, or uncaring of the art world or culture as a whole. The officers and detectives involved in art theft investigations are duped and made to look foolish by clever and classy thieves. The thieves themselves are depicted as well educated, socially adept, and extremely heedful of the artwork. They are portrayed as clean cut, stylish, and handsome. Law enforcement, on the other hand, is portrayed as motivated to put these thieves behind bars, simply because the thief is

wealthy or because of pressure from the public and their superiors to catch the pillager. As a representation of the entertainment industry's portrayals, the following three examples depict, first, a well-educated and wealthy lover of the arts who steals for pleasure and excitement; second, a suave and debonair con man working with the FBI; and lastly a group of likable thieves. The viewers are enthralled with the thieves; they hope the thieves win, beat the odds, outwit the cops, and make it rich. We feel for the characters; they make us laugh; and best of all, they are nice people.

The Thomas Crown Affair depicts a businessman, for whom the movie is named after—played by Pierce Brosnan—who in his spare time plans and executes elaborate thefts of artwork. In his day-to-day life, he is in charge of a company called Crown Acquisitions. In this position he conducts trades and purchases with other companies, often making a considerable profit. He is famed for being able to sell and purchase by outmaneuvering his opponent, and always getting the deal signed.

Crown comes under investigation by the police, and by extension an insurance investigator, after he steals a painting from the museum. He creates a diversion by using other thieves and outwitting security by using a specially made briefcase he has hidden in the museum. He then displays the stolen painting in his private office in a secret compartment. The audience is led to believe that he steals simply for his own enjoyment and love of art.

He returns the painting to the museum under the guise of a donation, painting over the original painting with water paints. This sham is later revealed when the sprinkler system is triggered by Crown in the final scenes. The movie focuses on committing thefts, avoiding the police, and never facing the consequences of being tried in a court of law. His motivation is spurred by boredom as well as his enjoyment of the art offered at the museum. Committing these thefts gives him an adrenaline rush, a sense of excitement that he does not get from his legitimate work.

The character, Thomas Crown, has enough money to hire the best lawyers, as well as groups of thieves to act as a distraction, while he steals from the museum. The story has us believe that this opulent wealth is enough to have custom-made briefcases built for him—without raising suspicion. Law enforcement is portrayed as being unrefined

and rough around the edges, blue-collar workers who know nothing and care little for the arts. Their motivation for catching Thomas Crown is primarily based upon putting someone with his wealth behind bars and less about recovering the artwork. At the end of the film, when it is revealed that the donated painting is actually the original stolen work, it is shown that Crown stole another work. The detective's reaction to the other painting being stolen is "Who cares? It's just a painting."

The truth about the police officers who investigate art theft is much different from the portrayals depicted in movies or television shows. The FBI agents within the art crime division are dedicated and serious about retrieving stolen art and returning it to the rightful owners, despite the lack of personnel required to combat this serious problem effectively. The fact is, there are not enough officers and agents that are familiar with the unique concerns involved in various art crimes. Conversely, the idea of the art thief as being suave and debonair is largely false. Many art thieves are simply robbers who seek highly valued items that are easy to steal and less cumbersome to transport. The majority of thieves are not educated on the history of the work and treat the artwork negligently. What is truly deplorable? When thieves are cornered or believe they will be caught and punished, they may destroy the art in order to be rid of the evidence. In the movies they are always the most educated about the works and have a knowledge base that is beyond realistic. In many cases the individuals who steal the works are not motivated by art, but rather steal for the money or the ransom paid by the owner, much like a guardian would pay the kidnapper for the return of their child.

Similar to *The Thomas Crown Affair*, there is a romanticized character on television with a taste for excitement, an adrenaline rush, and pursuit of danger. *White Collar* is a show that aired on the USA network from 2009 to 2014. It features the character of Neal Caffrey—played by Matt Bomer—as a conman and master forger who has a deep-seated love of art. He wears the finest tailored suits, has perfectly combed hair, and can converse on any highbrow topic with the utmost intelligence and eloquence.

Caffrey, an ex-con, works as a consultant for the FBI, under the supervision of the agent who caught and arrested him—twice. Throughout the show he displays charm and charisma. No woman can resist him and he manages to seduce every woman he comes in contact

with, except an FBI agent who is revealed to be gay. He has the ability to adapt and con his way into and out of almost anything, while also having an exceptional knowledge of the arts, along with the ability to forge anything, both currency as well as art, with impeccable accuracy.

The show is based around Caffrey joining with the FBI's white-collar division investigating a wide range of crimes from forged bonds, art crimes, to fraud. Caffrey was released from jail specifically to work with the FBI, so there are conditions on his release. Utilizing the conditions set by the court, he resorts to a variety of "outside the box" methods, breaking the law himself, so the FBI has to track him down, and therefore gain legal access to crime scenes for which the FBI would otherwise not have enough evidence to authorize a warrant.

Caffrey shows a considerable ethical and moral compass when it comes to preserving art and dealing with serious issues, including a strong dislike of weapons. He does display a disregard for authority and rules that gives him a charming and likable character. In the first episode, Neal works his way into living in a mansion in New York City by befriending a widow. The FBI agent (played by Tim DeKay) states, "I follow the rules, I do everything right, and I don't have a multi-million-dollar view of the city," to which Caffrey replies innocently, "Why not?"

Audiences like these type of characters because of their risqué uniqueness, while at the same time implying that they are noble individuals. The use of a sophisticated character who does not like violence or the use of guns implies that, deep down, through all their wrongdoings, they are a good person. Their use of crime and interest in crimes is a representation of their innocence and their free-living lifestyle. In many cases these individuals are portrayed as geniuses that can pull facts and supply information off the tops of their heads at remarkable speed.

In portrayals of extravagant and exciting robberies, the viewers are not informed of the owner of the stolen goods and have little to no idea of who is being robbed. It appears that in the few cases when the audience is told who the victim is, that victim is portrayed as "evil" or far too wealthy, vain, or wasting of their wealth to justify the items being stolen. In this way the viewer roots for the robbers, and the theft of whatever is being stolen is considered earned or simply viewed in a positive light.

The movie *The Italian Job* is a prime example of the entertainment industry's ability to sway the viewer's point of view to justify rooting for the thieves. Each member of the team is memorable in a variety of ways: one is charming, another is awkward and nerdy, the other is a born leader, and another character likes explosives and hates dogs. The team is memorable, and the fashion in which they perform their heists is so entertaining that the audience does not give any thought to who is being robbed. The instance when the audience is given information on the victim is when they steal from a team member who killed their oldest member after robbing them all. The plot's revenge angle is meant to, once again, justify that the theft is legitimate; they are outwitting their friend's killer by having their stolen gold returned to them.

The film depicts a team of thieves, each having a history of stealing, or committing crimes in a unique manner. The movie begins in Venice with the team stealing a safe full of solid gold bricks. The theft is planned perfectly, with the team using explosives to blow the safe through two floors, cracking it underwater, while another part of the team conducts an elaborate chase on the waterways of Venice with a fake safe. After the successful getaway, one of their own team members robs the rest of the team at gunpoint. The team leader is shot in the chest, and they are left for dead at the bottom of a partially frozen lake. The rest of the film is the team preparing to steal back the remaining gold from their old team member, to exact revenge, as well as making additional cash.

The final theft is pulled off by blowing an armored car through a street and into a sewer, and offloading the gold onto a series of retrofitted Mini Coopers, driven expertly to a waiting train car. The audience is rooting for the thieves the entire time, never giving a second thought to the individual who was robbed in the first place. When the audience does know the story and the identity of the person being robbed, these characters are murderers or impolite lowlifes with very few redeemable qualities, if any, and the audience is relieved when he loses everything.

This theme is popular, particularly in terms of large groups of thieves, with each thief's personality being memorable in some way. This is evident in any of the *Ocean's* series, as well as most movies depicting similar groups. The viewer grows fond of the thieves and does not consider who is being robbed. If the person owning whatever is being stolen were likable, the viewer would be conflicted by their fond-

ness for the team. As such the "victim" is either portrayed as evil or undeserving in some way, or simply isn't portrayed and identified at all.

If one stops to consider who the art theft victim is, you would have to say, for museum art works, it is us, the general public; we are the victims. Homeowners that are invaded by thieves to steal valuables can hardly be lumped into a category of undeserving. We do not believe society is particularly evil, nor do we believe the thieves are art lovers or caring individuals, yet how much of the entertainment industry's portrayal influences the general public? Reviewing the news media sources is one way to determine the slant on the news. What are the differences between CNN and Fox News or *Time* magazine and local newspapers? Is there empathy for the owners of stolen items? Are the reports balanced or embellished? Are they newsworthy or simply a titillating story to sell the news?

News articles and newspapers show an interesting array of themes when it comes to art and cultural crimes. There is a tendency to focus on the Isabella Stewart Gardner Museum because it is such a hot topic for news and entertainment sources. This interest is valid considering that it ranks as the largest value placed on a single theft of art. Many articles on individual art thefts are derived from direct quotations or statistics within the United States, often citing the FBI or other law enforcement as their primary source of information.

When it comes to cultural warfare incidents, or looting and destruction of archaeological sites, news articles are relatively rare. The *New York Times* and *USA Today* report on cultural warfare more than other media sources. In many cases the destruction of archaeological sites is only reported when it ties into terrorist organizations such as the Islamic State of Iraq and al-Sham (ISIS) or the Islamic State of Iraq and the Levant (ISIL), which has become a hot topic for readers.

Some news sources, commonly considered more conservative, such as "Police Grant Help" through PoliceOne have very little information on art crime, and a search of their articles turned up a story focusing on an officer with a background in art. The closest this source came to representing art crimes is stating that officers and investigators use drawing and sketches or computer-generated programs to find and arrest the people who commit crimes.

Despite the lack of news on art crime, a number of sources have a reasonable number of articles on the subject matter, in some cases over

a dozen articles in the past four or five years. The information is still difficult to locate; often these articles and stories are buried, rarely making the front page of the news. The *New York Times*, *USA Today*, the *National Enquirer*, and Fox News, as well as some local papers, will pick up art crime stories if deemed newsworthy. Media representation in this area is generally impartial, other than one article by Fox News that added a political slant to the story. In a story regarding the Isabella Stewart Gardner Museum, it stated that the two main FBI suspects believed to have committed the thefts are no longer alive. As an aside, the article mentions that George Reissfelder, one of the suspects, was available to commit the crime because his lawyer John Kerry, the future secretary of state, had his murder conviction overturned years earlier. This is the only bias reporting found in the media regarding art theft with a political point of view. To the casual viewer, this subject is seen as a minor issue or as a romanticized method of committing theft, while those who are policing and studying art crime see it as underrepresented in the media as a serious concern.

Scholars also find similar issues in attempting to find definitive statistics on the subject. Because there is a vast array of art crimes, from stolen masterpieces to minor thefts from private collections, from fraud to the theft and destruction of antiquities, as well as political and religious debasing of cultural heritage sites, there is a large number of definitions related to this area. Reports of art crimes in the media cover a wide range of thefts and crimes. Anything can be found: a stolen Stradivarius violin, war crimes in the Middle East, an officer finding stolen artwork in a meth lab. Even definitive statistics by official agencies and organizations are vague and almost impossible to find, leaving researchers guessing at the severity of the issue by combining unofficial reports.

2

WHY DOES ART MATTER?

In an age where we are all besieged with countless news stories of shootings, robberies, terrorist attacks, and warfare, focusing on other aspects of our culture becomes a difficult and lengthy process. The question of priority becomes an issue when considering art crime against other crimes. Many other crimes come to mind that may be more pressing to human life and well-being. Within the United States, there is a serious neglect of art as well as that of art theft and fraud and its connection to violent and international crimes. Before being able to recognize fully the impact of art theft and fraud, we need to first examine the role and effect of art in our education, career performance, status, and ultimately, lifelong interests.

Why should anyone "waste" their time, effort, and money for a simple work of art? By many interpretations art is overpriced, too intellectual, and overall completely impractical to anyone's day to day life. Art doesn't feed the starving, nor does it provide protection for those in need. In a variety of opinions and perspectives, art is a waste of time, money, and space. The mere idea of putting more time and effort into protecting artwork seems a waste, especially considering the more pressing concerns that face our personal and national security. This perspective, unfortunately, is common among those with a blue-collar lifestyle and a more conservative political opinion.

Many who were students can remember sitting through countless history classes in junior high and elementary school, listening to the teacher lecture on about events throughout history, referencing the

lecture from what we read in long and boring textbooks. The events seem dry and distant and difficult to relate to. In many cases, students forget about the events the second they leave the classroom or take the test; the knowledge from class lasts long enough to receive a grade, before being replaced with more pressing aspects of day-to-day lives. At that age the more pressing matters often relate to love or figuring out what to do for the upcoming school break.

While many students get the chance to visit museums and view fine art through various field trips, it is often viewed as a break from the classroom. Few students are taking the time out of their day-to-day lives to simply wander in museums, enjoying everything that is displayed so proudly and elegantly. There is a sense of wonder and peace in taking the time to wander the quiet halls of your favorite museum, being able to take the time to admire the works that the artists and creators put countless hours into creating hundreds of years ago.

Even a TV show such as *White Collar*, which shows the thief being motivated by wealth, shows a reverence toward artwork and the cultural significance of the art. At one point the main character, Neal Caffrey, states, "Art captures a time, a place, an emotion."[1] The idea is put forth that each work of art isn't as simple as a photograph of an event, or a chapter in a book about history. Rather each work of art creates an emotional context, and a connection with the artist's perspectives on the subject matter.

These works describe historical events, events we may or may not have heard of, in a way a textbook or lecture never could. It literally can paint an image or create the feeling of being present at the time of that event. Art doesn't simply show a pretty picture or something you can decorate your house with. Artwork, in its utmost significance, displays an emotion, a feeling associated with an event. This type of emotion is difficult to portray through other mediums, and without this demonstration it would be difficult to see and feel the way the artist actually felt about an event that otherwise would have been lost in recorded history.

In the contemporary world it is becoming increasingly easy to obtain footage of current events, and as we move forward, anyone with access to the Internet will be able to see firsthand footage and reporting of a specific event in recent history. However, this is not an option we have for many events prior to the technological revolution. The events are

described not only through writings, and much of this has been pre-served, but also by the images displayed within our museums and galleries. These objects are literally a painted and carved history of specific events, giving us the ability to see the firsthand accounts and perspectives of those who were present.

We are barraged by an almost limitless amount of information every day. From the various advertisements on our commutes to work, the ads that play on the radio, all the papers delivered that attempt to capture our attention, and not to mention the continually growing amount of information on the internet. With so much information constantly at our fingertips, or attempting to change our minds and alter our opinions, we become desensitized to the truly informational and helpful articles or stories. Classes in undergraduate schools focus on teaching students to sift through the copious amounts of available information in order to find accurate and reliable sources.

The mere fact that students need to be taught to sift through the useless information clearly demonstrates how large amounts of data can be obtained with relative ease, along with how that information is false or misleading. Because abundant information is easy to find on almost any subject, it is commonplace for students to use the first source they find while conducting research. Citing a number of questionable sources can easily convey a perspective that lacks actual facts. Access to peer-reviewed sources is often limited, and students have to be taught to sort through those sources.

When it comes to the amount of information, particularly in the cases of politics and historic events, an artist's interpretation can quickly sum up the material in an easily understood manner. By creating a specific image, story, or lyric, artists for years have taken their opinions, and their observations, and made them easy for almost any viewer to access. Whereas an artist's depiction is concise and specific enough to capture in a brief moment, what technology and online news offers us is a continual barrage of information. Those viewing the artwork have the opportunity to examine it, and think about the artist's intent in order to better understand where the artist is coming from and what they are trying to demonstrate. While online it becomes a matter of sorting through the countless advertisements and information in order to find what you are looking for or something that is somewhat accurate.

In respect to the historical and cultural context of classical art, many are under the unfortunate assumption that only the highly educated or wealthy have an involvement in the arts. A recent study by the National Endowment for the Arts describes a growing trend: people of all ages and from of a variety of economic backgrounds are becoming involved in the arts. It is actually becoming fairly common to those of less wealthy backgrounds to be involved in artistic endeavors.[2] In many cases these artists seek out art as a way of having their voice heard by the general public. It is also becoming increasingly prevalent to see artists who have been traumatized at some point in their lives using art as a method of channeling their own pain by creating a beautiful and constructive outlet for that emotional history. Some of the greatest artwork can come from some of the greatest pain, and some of the most powerful messages come from that same artwork.

While the artists come from a variety of backgrounds, their shared interest in art exposes them to a wide range of ideas and styles that aren't normally thought to be in the same category. Many painters study sculpture in order to understand three dimensions and better utilize that perception in their paintings. Potters will take courses in drawing, as well as painting, in order to add accents and different styles to their work, even using sculptural elements to build a unique style that is all their own. Musicians will study a wide variety of musical styles; for example, modern hip-hop artists may have a background in classical styles. As far as the mainstream media, famous actors have backgrounds in classical theater and dance styles. The idea of artists being solely educated in their area of expertise is horribly misinformed, considering many artists seek out other styles in order to further their own personal designs and talents.

The study conducted by the National Endowment for the Arts on public participation stated that the strongest predictor of cultural engagement was in fact the education attained by the individual. Students involved in artistic endeavors within the education system and those raised in families with an appreciation for the arts are more inclined to participate in the arts throughout their lives. The trend has shown that those with an artistic background are more likely to bring that background into their future careers. As we have stated before, the study did point out that those with a higher occupational status, or having a prestigious position in their fields, have a higher appreciation of various art

forms. The appreciation of art was not solely focused on typically "high-brow" styles of art, such as the opera and classical art, but also included the other forms as well, such as music concerts and less formal visual arts.[3]

Statistics and surveys demonstrated a varied attendance to most types of art forms and functions, especially in terms of the ages of those attending. Art museums were the only area that showed the highest attendance between all ages and genders. The mindset of those who were actively involved in cultural participation and the arts showed that they were no longer letting their social status define what cultural acts were significant for them. Those typically thought of as "high-brow" were present at a large variety of artistic events and organizations, demonstrating again how higher education can improve individual artistic and cultural participation. The National Endowment study also addressed those getting involved in the arts. Involvement was less dependent on age and more about the individual's ability and willingness to connect with the aspirations of potential artists, as well as keeping an open mind when viewing new types of art styles.[4]

The arts, however, are a fairly broad category. The National Endowment for the Arts study focused on a number of different artistic outlets, such as music, video, and modern visual arts. Many examples of this variety can be seen within the growing trend of specialized arts high schools. Many students will gravitate toward arts high schools in order to avoid the harsh social constructs of public schools. These schools have a variety of areas of focus, visual arts, music, dance, theater, literature, and so on. The students who attend these schools aren't always the ones who can afford the best schools, but in many cases come from a wide variety of backgrounds, as the study states.

The arts offer a voice to those who often cannot channel their perception through the traditional educational system. An arts school, or an arts department, can offer students a broad variety of ways to learn that are unconventional, forcing them to think differently from the norm about the arts subject matter. As such, many students gravitate to the arts because it can offer them a new and unique way to approach their school work—or in some cases a welcome change of pace from the more typical work assignments they deal with on a day-to-day basis.

For many who feel they cannot express their perspectives and opinions in a traditional manner, such as going through government peti-

tions and hoping to be heard, the use of artwork offers a variety of mediums to these individuals within which they can accurately represent themselves to the viewer or the world as a whole. By using the artwork to convey their ideas, the artist can approach the subject matter from a wide range of senses. Those who are viewing the work can interpret for themselves most of the meaning behind the work; however, if done correctly, the viewer will see the perspective and the opinions of the artist through the artist's eyes. Being able to see a problem or a perspective through another's eyes offers valuable information and can convey far more than mere words ever could.

While those who have the ability to collect the classical works of art—which in many cases are worth hundreds of thousands, or in some cases millions of dollars—are those of wealth and high station, the individuals who seek to learn about the arts, study the works, and create modern examples of artistic expression can be from any background. It is often said that many artists are only famous after they die, and in many respects this can be true. Many artists were not recognized for their genius and talents until after they had died—in many cases tragically. Artists such as Vincent Van Gogh, El Greco, Johannes Vermeer, and Paul Gauguin were all visual artists who weren't recognized until long after they had passed away. Even writers such as Franz Kafka, Edgar Allen Poe, and Henry David Thoreau weren't as recognized or highly respected during their lives. This is also true for musicians; Johann Sebastian Bach, for example, died before his work was truly appreciated, and he is one of the icons of classical music.

The variety of backgrounds in the arts world creates a diversity of perspectives. In films you can see metaphors for current politics. In music you can hear those speaking out against or for current events. In theater, you see both re-creations of the classical works and also those works focused on current events in the world. It does not matter what art form you are viewing: you can see anything from replicas of past masters to current interpretations of modern events. This holds true for historical works as well as those that have survived to the modern day.

Museums offer a serious cultural value to society. They serve as a public location and a center of classical and modern artworks. Museum locations are known internationally and in many cases serve as a positive reinforcement for the local economy via tourism from international travel. In many cases these museums are household names that hold an

air of prestige and sophistication. The Guggenheim in Manhattan, the Metropolitan Museum of Art (commonly referred to as the Met) in New York City, the Louvre in Paris, and the Uffizi Gallery in Florence—each of these museums, and countless others, are easily recognized by the majority of those of any educational background. Many of these world-renowned galleries are also parts of academic organizations, providing an educational background to the visitors as well as a visual display for those attending nearby schools.

Studies have indicated that museums and galleries in the past were initially attended as highly as modern sporting events and music concerts.[5] So what has changed? How has our perspective of culture changed over time? How has our ability to access the information changed our ability to be entertained? Is it based upon our perspective of our own culture and how that culture changes over time?

Museums still maintain a significant impact on our cultural values. This can be witnessed by tourism rates, considering many tourist attractions are art museums or galleries, rather than sporting arenas and fields. In Europe, attendance and visitation to museums, national monuments, and architectural wonders are one of the primary contributors to the overall economy.[6] This is mainly due to the long histories of the various locations and items; yet it offers a great deal more to the overall cultural value and mindset than merely an economic value.

When visiting Europe, it is almost an expectation to visit the famous museums or the ruins of an ancient civilization, often realizing that you are standing in the same structure that others would have stood in hundreds or thousands of years ago. When living in the center of a historic area, we can easily become desensitized to the cultural and artistic wonders that surround us. While art and galleries can be viewed for their cultural significance, it is also important to recognize the value these mediums play on our personal and emotional states of mind.

The idea of art and architecture is so much more than something we can view for our own pleasure or to gain a better understanding of our cultures and histories. Rather it affects our country and our culture in a variety of ways. Not only does art give us an economic boost or a way to express our views and opinions in unconventional ways, it can also be used as a teaching tool or as a method of conveying thoughts and ideas that many students have trouble understanding through classwork.

Art is now used in a number of different ways, not only within a teaching capacity, or as a display in museums, but also in the field of mental health and recovery. Most schools feature a variety of art programs that allow for different ways of thinking than many lecture-style classes. Now art therapy is becoming common for those suffering from mental disabilities, in particular Alzheimer's disease. Once again, art is a wordless method of conveying feeling and emotion. Those suffering from mental handicaps cannot always express themselves verbally or communicate effectively the way they desire. They may reach out through their artwork, especially for those suffering from dementia. While their memories may not always be present, music or visual art can, in many cases, provide that connection that they have so much difficulty making by themselves.

The American Art Therapy Association posts a detailed amount of information on the subject of art therapy. In particular, it focuses on those with mental health issues. The art therapy is used to allow the patients the ability to represent their thoughts and emotions through the use of artistic mediums. By focusing on these different forms of representation, these patients and individuals have the ability to present their thoughts in ways they couldn't normally with words and more common communication methods.[7]

By exploring their own feelings, and representing what they feel in a different medium, the patients are able to approach their health issues with a completely new and different perspective. This process helps considerably with issues pertaining to anxiety, increasing self-awareness, developing social skills, and improving their self-esteem. By the end of their therapy, they gain the ability to function in society to a degree that couldn't have been possible without the art therapy, and in many cases this cannot be accomplished with traditional therapy methods.[8]

Using art as a therapy method speaks a great deal to the different ways that art connects with our memories and perspectives. The use of artwork allows people of all ages to represent or connect to aspects of their mental traumas or memories that otherwise could be difficult to describe and face. Art becomes a method of revealing what is most personal to the individual and giving shape or form to something they cannot express in words. The use of art as a method of therapy demon-

strates the ways in which the various mediums can connect those of different mindsets and perspectives.

The idea of art strictly benefiting people on a personal or individual level doesn't do the subject matter enough justice. Many countries feel the need, and rightfully so, to classify art crimes as cultural crimes. The destruction or general loss of any work of art can severely damage the cultural identity of a country. In many ways each work of art is a monument to the culture's identity. As such the loss of a painting or sculpture in many countries would be similar to the loss of an American monument for the United States. In the case of these smaller works, the impact and damage to the cultural identity is so much larger than the physical work itself.

Art is a type of a first-person perspective on historical events. In a way the viewer of the artwork is seeing that artist's interpretation of an event that the viewer couldn't understand or interpret through reading about it. In the words of Fred S. Kleiner, "People cannot see or touch history's vanished human events, but a visible, tangible artwork is a kind of persisting event."[9]

The destruction of the Twin Towers of the World Trade Center on September 11, 2001, is something that continuously affects the American mindset. In many films, the destruction of American monuments and architecturally prominent buildings is used to create a sense of shock and awe. The destruction of the White House, especially, is seen as a direct attack on America, rather than simply the destruction of a building. Why are these crimes considered terrorist acts while the destruction of artwork is not, even though both may cause similar damage to our cultural identity?

A country's culture is defined by various moments throughout history. In many cases these moments are represented and defined through artwork and monuments. For Americans these icons come easily to mind—the Lincoln Memorial, Ground Zero, and the Vietnam War Memorial, to name a few. Architecture, famous painters, music, even the design of the streets themselves play a part in the definition of cultural identity. It is impossible for anyone to think through their culture's history and not in one way or another view the identity displayed or defined through artistic representation. As such it is impossible not to understand the full impact of a culture's reliance on these objects, as well as the importance of maintaining them.

One can easily identify the difference in architecture from urban American to Italian to Spanish styles. You can easily notice the differences between the streets in urban America and Amsterdam. In many European cities the streets are made of cobblestone rather than asphalt; they are built for pedestrians, not vehicles. Buildings are also closer together, making the areas more amenable to walking or biking. The result is a more relaxing atmosphere, which is reflected in those residing there.

It is easy to notice in many American cities that life in an urban environment is very business oriented. It is rare to spend time wandering around or relaxing while admiring the architecture surrounding you. There is also pressure to strictly adhere to a schedule; we must always be on time or be early. We operate at a rapid pace that is very much a rarity in many European countries. While this isn't true for everyone, it is true for the vast majority who tend to focus on where they are going and what they need to do, rather than enjoying the various sites surrounding them. This represents much of the American culture, which is focused on productivity and career advancement rather than simply taking the time to relax and enjoy the here and now.

The opposite is true for many of the Western European cities. Taking the time to relax, sip coffee or wine, and enjoy the surroundings is built into their daily schedule. To many Europeans, the American focus on ease of access and productivity is completely foreign. Of course in cities such as Venice, where the primary vehicle of travel is a boat on the canals, it is difficult not to take the time out of your day to admire the surroundings. Being constantly surrounded by such history, the inhabitants would find it nearly impossible not to fully appreciate everything.

To visitors of whatever cities and neighborhoods we call home, and to the tourists who travel to see the landmarks, everything about our day-to-day lifestyles, including the way we build our structures and design our streets, gives a clue as to how our culture behaves. If our cities eventually become run down and uninhabited, what we leave behind and preserve will tell the story of our culture to those who follow and uncover the ruins of our lives. The style of architecture, the layout of the streets, and everything that might be left behind tells a story of who we are.

Through archaeological discoveries, the remnants of many cities tell countless stories about the lives of those who lived there. Many of the artifacts from these ruins, priceless works of history, are now displayed within our museums. Carefully sorting through each and every ruin, archaeologists meticulously unearth each artifact and document its placement and orientation in order to properly understand how it connects to the cultural values of its people.

The only reason many know of the rituals surrounding ancient Egypt, or the legends of the ancient Vikings that are becoming increasingly popular in the media, is because of the ruins, artifacts, and artwork that historians have used to interpret the details of their lives. While these civilizations may have stories that have been handed down from one family to another, the histories are found through what is left behind. Ancient Roman and Greek architecture still plays a distinctive role in modern architecture, and the cities themselves—Rome, Paris, London, Venice, and Florence, to name a few—are cultural icons that represent the center of the cultural and art world.

It is impossible to find a distinction between art and culture. A city's cultural identity is so represented by its artwork that the work itself both creates and describes the culture simultaneously. When someone thinks of their own culture, they think of the food, the artwork, the architecture, the myths and legends, the music, the dance styles. Even the adherence to day-to-day schedules and the mindfulness of punctuality is defined by the culture. In the end, the various artistic styles that are visible are a representation of that culture as well as a defining factor of the culture's identity.

How will our civilization be remembered? If we were to cease to exist completely due to some catastrophic event, but our artwork, our buildings, and every object in our homes were to remain exactly as they are, what would those who came after us think of the way we live and what we truly valued? Would our architecture and monuments display an ideal of democracy and freedom as a country or a sense of superiority and pride in our military might? How would we compare to other cultures and countries, countries that place more value on their cultural heritage rather than on material possessions?

3

WHAT IS ART CRIME?

So what exactly is art crime? As we have discussed previously, the topic brings to mind images from the media and popular television shows and movies, many of which depict different types of prevalent art crimes. Theft, destruction, forgery, and looting are some of the primary terms used to describe art crimes. The terms themselves don't always convey the process of the crime or the resulting damage caused. As such it is important to fully understand the differences, and the impact each of the crimes have.

The theft of artwork is one of the most common criminal forms. Normally it is thought of as being straightforward, the thieves stealing the work in order to sell it to someone else, and as such, making a profit. Crimes involving artwork are unique due to how difficult it is to sell easily recognizable items on an open market. The artwork often sells for less than 10 percent of its value on a black market.[1] Because of this, thieves need to either have a buyer already lined up or risk being discovered while trying to sell a work.

Most thieves recognize this issue when attempting to sell these stolen items on an open market. Any stolen item will be sold for far less than its original price. This is equally true for stolen cars, stolen jewelry, and other traditional examples of property crimes involving theft. The theft of artwork, however, becomes widely publicized and the work stolen is usually quite unique; if it is seen it will be recognized immediately and ideally be reported to the proper authorities. Currently many agencies around the world keep a list of stolen or missing works of art;

by displaying this list, they keep the public aware of what's currently missing and encourage tips should these works resurface on the various markets.

The theft from the Isabella Stewart Gardner Museum, located in Boston, Massachusetts, is easily the most famous theft of artwork in history. Taking place on March 18, 1990, the two would-be thieves took advantage of the St. Patrick's Day celebrations and came upon the museum after it was closed, gaining entry by dressing as police officers and wearing fake moustaches. The thieves told the guards at the museum that they had received an alarm call and wanted to check and make sure everything was in proper order.[2]

Once the two thieves got inside the museum, they overpowered the two guards and bound them in the basement to some piping. At this point the thieves disabled the security cameras and took their time to go through the museum picking and choosing which works they wanted. By the end, the thieves left with around $500 million worth of art in their possession, including a Vermeer, multiple Rembrandts, and five sketches by Degas. These works are still at large, as are those responsible for this heinous theft. Those who visit the museum can clearly see where these works were once displayed, as the empty frames of the paintings remain in their place, haunting the visitor with the loss of the great works.

Because the works were so high profile, the Isabella Stewart Gardner Museum initially believed, as many museums do, that the thieves would barter with the museum for their safe return. As such, many thieves resort to treating these works as many kidnappers would treat their victims. By adopting this perspective, the thieves' overall goal is to ransom the work back to the owners. Ransoming art makes it possible to make more money from stealing the work, and it avoids the problems of attempting to fence an item that is so easily recognizable.[3]

In many cases the demands for a ransom come fairly quickly after the immediate theft of the work, ideally avoiding the involvement of any law enforcement. Considering the rarity of the works, the owners will pay almost any price under the open market value in order to have it returned in good condition. The thieves can easily ransom the work, making considerably more than a measly 10 percent of the black-market value. The fact remains that by ransoming the artwork, the thieves have less chance of being caught by authorities. It is a much safer—and

profitable—illegal transaction by which thieves may rid themselves of a work of art that is easily identifiable as stolen.

One aspect of art theft, portrayed by the media's interpretation of the subject matter, is the idea of a thief or collector stealing the work in order to appreciate the beauty and wonder. Scholars have debated this popular media theme—an art collector stealing in order to increase their personal collection. It is a difficult scenario to prove as well as to disprove. There are very few cases of individuals stealing work just for their own private collection; on the other hand, there is also very little evidence to disprove this idea. What has been proven is that the majority of thieves show very little care for the artwork.

One of the few exceptions is an art thief by the name of Stephane Breitwieser, a Frenchman who traveled and admittedly stole 239 works of art amounting to about $1.4 billion. The one thing that makes Breitwieser stand out is that he never sold any of the works he stole; he committed these acts because he loved the art. Many of the thefts took place while he traveled Europe working as a waiter. He would have his girlfriend, at the time, cause a distraction, and he would simply slip the works under his clothes when nobody was looking. During his trial, Breitwieser was able to recall each and every one of the 239 works he stole, describing the minute intricacies of each. These works were stored in his bedroom at his mother's house, and upon his arrest, she destroyed many of the works by shredding them with scissors or grinding them in the garbage disposal.[4]

The thief who steals for the love of art is sadly in the minority. Very few thieves take the time to care for the artwork, and in many cases will unequivocally damage the work in the process of stealing it. In the instance of the Gardner heist, the thieves physically cut the paintings from the display frames. When such thieves are faced with going to jail or paying fines for their crimes, their reaction is often to destroy any evidence that could link them to the crime. In these cases, this involves the destruction of historical and iconic works of art that are priceless and irreplaceable.

Many criminals may decide to go about the crime another way. Instead of stealing a work, and it being discovered as being stolen, they could simply duplicate it and sell it as the original. While the seller may be recognized for attempting to sell such a recognizable work, they won't attract the same attention if the work is known to be stolen. It is

also possible that the individual could steal a work of art and replace it with their own copy in order to prevent the authorities and owners from realizing it was ever stolen in the first place and thus avoiding any investigation altogether.

A major problem with forging artwork is deceiving anyone who attempts to authenticate it. The methods used to authenticate are done by experts in the art world; scientific tests are also conducted in order to gauge the age of the works. Experts can verify if it matches the style of the artist's other works by looking at brush strokes, minor flaws that are common with the artist, and evaluating the materials and subject matter. They can also take tiny pieces of the work and test them for age and authenticity of the materials used. If the material used matches up with the materials in other works or with materials common in that era, it increases the chances of it being authentic.

The Victoria and Albert Museum in London, England, has actually opened a display of forged works of art. It has displayed more than a hundred forged works that if genuine would be worth approximately $6.45 million in the United States. Each of these works were seized by the police in England. Detective Sergeant Varnon Replay, who previously led the Metropolitan Police arts and antiquities unit and is now the head of security at the Victoria and Albert Museum, stated that it wasn't always the rich and famous who were the victims. Many of the artworks that are forged amount to less than $15,000. This is in order to attract less attention since the work is less likely to be as closely examined.[5] It is easier to keep track of the famous works or notice when they return to the market after being stolen than the less-famous works. The latter aren't as closely monitored because the worth of the item isn't as valuable. The attention of law enforcement and the public eye is almost always centered on the higher price tag associated with the work.

A forgery, however, isn't as simple as copying a work of art. If it was then there would be thousands or millions of forgeries of famous works in circulation. In order to develop their eyes and hands by creating similar styles, many art students will practice and attempt to improve by copying the great works of past masters. The only way that these works would be considered forgeries is if the creator, or another, attempted to pass the copied work off as being the original. This is often done in order to gain prestige or to sell and gain wealth. Those in law enforcement who are tracking forged works need to be able to prove that there

was intent to sell the work as the original in order to qualify it as a forgery.

Another aspect that makes identifying forgeries more difficult is the fact that many scholars debate the creator of various works of art. Many of the individuals who originally authenticated works of art were paid a commission based on the fame of the artist whose work they discovered. As such, many artworks that were originally attributed to famous artists over time have been reattributed to other famous artists as they were discovered, and in some cases been attributed to the previous artist or to completely unrelated artists.[6] Today, many artworks are still reattributed to different artists. With the advancements of technology, authenticators can analyze the brush strokes or materials being used and compare them to other artistic works.

One of the prime examples of a misattributed work of art is the *Adoration of the Mystic Lamb* by Jan van Eyck (later presumed to have been started by his brother Hubert van Eyck). One panel from the altarpiece is even questioned as a possible forgery. Another example was discovered at Queen's University, where professor Ronald Spronk discovered that two works of art thought to have been created by Hieronymus Bosch could not have been authentic due to a number of scientific tests that would prove that it was produced at least nine years after Bosch's demise.

Fraud is directly associated with forgeries; it is the act of selling, auctioning, or advertising the forged work and thereby convincing the buyer or viewer that it is the original. This is done to accomplish a number of different goals. In many cases the individual attempting to pass off the forgery as the original will do so in order to make a sale and receive a payment for the painting. In other cases, these individuals will pass off the painting as the original expecting to use it as a centerpiece for an auction or as promotion for an exhibit; by doing so they create a centerpiece that is easily recognized and highly publicized.

Many museums will hold onto prized works in order to increase their display's notoriety, which can increase publicity and attention for a gallery. The increase in publicity raises income and fame, improves the chances for better exhibits, and creates a higher renown in the art world. In many cases the individual attempting to pass this work off as the original hopes to donate the work to an exhibit, increasing their own renown as well as the profits from the exhibit itself.

A New York art dealer recently pleaded guilty to this form of art fraud. Glafira Rosales, age fifty-seven, had spent more than fifteen years selling over $80 million worth of fraudulent art to various art collectors and art connoisseurs. With the sales of over sixty-three fake works of art, Rosales defrauded the art galleries of over $30 million. Along with the charges of art fraud, Rosales also faced charges of wire fraud, tax fraud, money laundering, and six other charges amounting to a prison term of over ninety-nine years.[7]

By selling artwork to various galleries and collections, not only do the dealers make a tremendous amount of money, but they also make it difficult to find accurate historical documents. It also deprives the public from viewing a work of art created by a master or renowned artist. While there is something commendable about an artist creating a forgery with such detail and accuracy that it could be passed off as an original, the mere fact that it is not the original means that the history of the work is severely lacking.

When an artifact is uncovered at an archaeological site, the work itself doesn't immediately describe a great deal about the culture's values. In many cases each item is meticulously documented by the archaeologist. By looking at the placement of each object, and comparing it to the surrounding objects or the importance of its placement in the room, the archaeologist can create connections and come up with an idea of how these individuals lived their lives. In many cases these objects show similarities between ancient civilizations and our own, creating a connection between how we live our lives today and how they lived theirs so very long ago.

If these objects are taken from their original locations, the history and connections are quickly lost. There is also another concern of the care for the artifacts and artwork. When archaeologists uncover a dig site, they spend countless hours ensuring that they don't damage any aspect of the work they are unearthing. Due to the age of the artifacts, as well as how long they have gone unexposed, it is easy to understand how delicate these items can be. If stolen from their original sites, there is a great deal of damage that can be done, not only to the artifacts and artwork themselves, but also to the understanding we have of that culture.

Looting is yet another aspect of art crime that damages the knowledge and ability to understand a work of art or cultural artifact. The

crime of looting is similar to theft of a work or an artifact. The difference is that it is taken directly from the dig site or the location from which it would normally be discovered. This not only deprives a museum or university access to the artifact, but it can also drastically change what we know about past cultures, as well as the overall culture, due to the loss of their historical representation.

This crime has become fairly common in third-world countries. It is difficult to completely assess how frequent the instances of looting are taking place. Looting itself isn't something that is widely publicized by the looter (for obvious reasons), and in many cases the sites being looted aren't even known to the public or the archaeological community. According to statistics by Interpol, the general number used to describe how many sites have been looted is "hundreds," while other sources state that between 60 percent and 90 percent of tombs and archaeological sites have been looted or pillaged. Many collectors state that these statistics are greatly exaggerated; of course this is possibly due to their profiting from questionable artifacts with a somewhat gray history.[8]

Due to lack of government control, or a poorer economy, selling looted artifacts became an easy way for locals to make quick money. It also became popular in war zones where government control was inhibited. Many Egyptian artifacts were originally looted from their early locations. Considering that many of the ancient Egyptian elite believed that the wealth they were buried with would accompany them in the afterlife, their tombs were a store of riches that have only increased in value over time.

There are individuals who prefer to take advantage of looted works and who have made a great deal of money in the process. The locals will be paid a small sum, not even close to what the artifacts are worth, in order to obtain the looted work of art. These dealers will then turn around and create false backstories or provenances of these works and sell them for thousands, drastically profiting in the process. Sometimes these same works make it to legitimate institutions where they are proudly displayed—until their history is traced back to a known illicit artifact dealer.

This happened to the Minneapolis Institute of Art in Minnesota. A prominently displayed work from Italy that had been displayed for years as a center of attraction turned out to be a looted work of art. It had

been obtained before detailed provenances were a standard at museums and was eventually traced back to a known dealer of illicit artwork named Giacomo Medici. Eventually the Minneapolis Institute of Art (MIA) returned this specific work, as well as all others obtained from the same dealer, to their ancestral home of Italy.[9]

Among all of the various types of art and cultural crimes, the destruction of artwork is arguably the most heinous. This is an act that has been used throughout history, sometimes in order to oppress another culture, sometimes in order to attempt to hide a crime. No matter what the reasoning for the act, the outcome is always the same—the permanent and irreversible loss of a work of art to the world, ultimately depriving anyone and everyone of a cultural icon.

There are many examples of the destruction of artworks. The Nazis in World War II destroyed much artwork when they realized the Allies were closing in on the locations where it was hidden, burning entire mines of stored artwork. Further back in history, it was used as a method of dominating or alternately subjugating another culture and nation by destroying their artwork. It can even be seen today by just looking to the current calamity in the Middle East. The groups known as ISIL (Islamic State of Iraq and the Levant) and ISIS (Islamic State of Iraq and al-Sham) have been in the news consistently for the destruction of archaeological sites used as a method of destroying any evidence of past culture or history that may disagree with their own views.

The use of destroying artwork has historically been used to put a final end to a culture's history and representation. Many conquered civilizations leave behind their artwork, and protect it in order to preserve their identity. As a final humiliation, and a final end to the conflict, many of the conquering nations will attempt to destroy all evidence of the original culture in the area. By doing so, they leave the nation both disgraced and without evidence of their cultural historical identity.[10]

While these crimes have been extremely prevalent throughout history, the idea of these acts being classified as crimes is a fairly recent advancement for world cultural preservation. Up until World War I, the victor of a war could plunder and take advantage of whatever they wanted through their victory. Prior to World War I, the international art community began a scholarly discussion regarding the protection and treatment of cultural sites during the course of war. During and imme-

diately following World War I, nearly all countries agreed that monuments should be preserved throughout the war. In many cases this was an empty statement, yet it still showed the inclination to protect cultural icons.[11]

Art crime has been growing over the last century. In reality this could be attributed to the ability to track and document various art crimes. Within law enforcement, the "Dark Figure of Crime" is a term used to describe the discrepancy between the crimes that are reported and therefore known to law enforcement, as opposed to the actual crimes committed. This figure isn't specific, but rather explains the wide range of statistics that are reported through different sources, some officially recorded from law enforcement agencies, while others are based on surveys from the general public.

This lack of knowledge can be attributed to art crimes as well. As technology advances, so does the ability to record and report the crimes committed. This could be one explanation for the seeming rise of art crime. Crimes themselves may not be happening at an increased rate but rather our ability to record and report them has improved, thus creating the perception that art crime is on the rise.

The value of art is increasing and has moved at an accelerated rate over the past century. With the increase in prices and value, there is increased attention from those wishing to obtain these high-valued items. Art is targeted by thieves because of the relative ease of stealing from museums and private collections. Many museums or private collections have little security in comparison to, say, banks. In addition to the lack of security, each work can sometimes be worth thousands or millions of dollars on an open market, and thieves know art is relatively easy to transport and carry.

To many thieves the theft of artwork is solely a method of making money. Based on this assumption, thieves believe they can receive close to the asking price. In reality, many of these works can only be sold at 10 percent or less of the full value.[12] Because of this many thieves resort to treating the work like a kidnapping; for example, ransoming the work back to the owner where they are likely to receive a higher payment.

Many authors and experts in the field have theorized that works of art are stolen for organized crime groups. The theory states that these crime syndicates use these works of art in order to barter and trade for weapons, drugs, and favors. As such, these works of art could stay out of

the public eye for countless years while changing hands to various criminal groups.[13] This avoids the heavy price in attempting to sell on an open market while also avoiding the heightened risk of discovery by law enforcement. While this theory is not proven, it does lend itself to the concept of organized crime groups who do indeed have a hand in the thefts of art. This idea must be considered by law enforcement due to the numerous ways that artwork can affect so many criminal enterprises. Artwork being used to trade and barter for weapons and drugs on a black market would link art crime to terrorism and directly to the drug trades. If law enforcement became more involved and took the subject matter to heart, they could focus on cutting a major method of revenue from a large number of groups that are using it in order to fund and trade for violence and death.

Even in the modern era, the groups ISIS and ISIL are looting works of art from the sites they are destroying and selling these works to third parties to raise funds for their activities. This is using the art as a method of trade and bartering; it is using looted antiquities to raise funds to directly further their efforts of violence and destruction. This is something that law enforcement is unable to stop, and the military simply cannot ignore. While focusing on preventing these crimes wouldn't completely disband terrorist groups, it would be another step forward in lessening their financial profiting from the destruction and theft of culturally significant objects.

In order for law enforcement and governments to take steps to prevent art crimes, they need to first understand the wide variety of crimes that exist within the world of art and cultural crimes. Once a full understanding is achieved, it becomes possible to completely respect the subject matter. Though it is unfortunate that so many do not pay the subject matter the respect it deserves, considering how difficult it is to find the necessary statistics and information, it is understandable that so few understand how serious an issue it is.

By classifying these crimes as art crimes, it does not do justice to the fact that history, culture, intellect, and scholarly works are annihilated. It is important that it isn't simply considered a property crime, as it usually is classified within the United States; it needs to be viewed as a cultural crime as well, as the United Nations views it. While the change in classification wouldn't completely alter the way art crimes are

viewed, it does open up the idea that these crimes affect more aspects of the public than simply a financial value.

Though the crimes may vary, they all amount to the destruction or alteration of culturally significant and beautiful works of art. By understanding the different crimes, those who investigate and research them can better identify and understand the damages they cause and approach crime scenes with the due seriousness they deserve. Those who investigate these crimes need to take the time to fully recognize the severe damage resulting from the loss and abuse of these objects, and by understanding the nature of these crimes, the specifics of how they are committed. By doing so, those investigating the crimes can better appreciate the need to catch and recover these priceless aspects of our culture and history.

4

HISTORY OF ART AND ART-RELATED CRIMES

The use of art crimes in order to further one's financial value or overall status isn't a new concept. The perspective that art crimes are in fact crimes is a fairly recent idea, as previously stated. Up until World War I, art crimes during warfare were a regular occurrence; in a way it was almost expected of the conquering nation. It was a common act, used for a number of reasons.

One of the primary reasons a nation would destroy or take the conquered nation's arts and heritage works was to display its own superiority over the defeated culture. In many cases countries would display the works of the subjugated in a museum or gallery, adding insult to injury. By doing this, the defeated country's cultural icons are displayed as trophies of war in the nation that conquered it, demonstrating a total dominance over the defeated.

A secondary aspect of destroying or stealing the defeated nation's cultural artifacts and artwork was to completely eliminate the culture. This can still be seen today in some regions; those destroying the artifacts and ruins do so in order to prevent that culture from uprising or reemerging. By completely destroying a cultural identity, the conquering nation denies the survivors the ability to rediscover their cultural identity and form a connection that could motivate others. This motivation could easily turn into a revolt and cost the conquering nation greatly in the long run.

When we address the topic of the history of art crime, we do not discount the history prior to World War I when it was commonplace and expected that during warfare the losing nation would be looted and pillaged. The conquering country viewed it as its right to take what spoils it could, and in fact this was the major motivation of many conflicts and wars that were waged.

Just prior to World War I it became clear that this past practice of destroying or taking another country's works was causing irreparable damage to the world's access to history and its overall cultural heritage. At this point it became a priority in warfare to avoid, if possible, needless damage to significant cultural sites and locations. Even in the modern day, this practice is being used by the United States' military. Archaeologists are employed to instruct soldiers going overseas of the different artifacts and buildings they may come across, as well as ways they can avoid conflicts in areas that contain culturally significant structures, to prevent damage in these locations.[1] Unfortunately, this cannot always be accomplished, and when the lives of the soldiers are at risk, there is little choice but to retaliate.

Napoleon's conquests led to the expansion and collection of art and the overall fame of the Louvre. As he moved from one region to the next, he made it a point to collect art and send as much as possible back to France. The museum was used to display the conquests of his victories and celebrate the power of the French military. The confiscated art made the Louvre famous, and those visiting France were able to view a remarkable variety of cultural icons without having to travel across Europe.

This period of time also saw the development of a military strategy to transport and oversee the removal of art during war. Napoleon's division was named the "Commission of Arts and Sciences," which was primarily dedicated to the retrieval and transportation of art back to Paris and was closely overseen by members of the French military, in particular a mathematician, a botanist, and two painters. While Napoleon encouraged and announced that the acquired arts and antiquities would be for the French government and would all be transported to Paris, the specialists who oversaw the division, appointed by Napoleon, soon started claiming works of art for themselves. One of these specialists conveniently became the first director of the Louvre and was responsible for its fast-paced rise to fame and renown.[2]

World War II marked one of the most horrific examples of looting and theft during warfare, let alone human injustices and genocide. As the Nazi military moved its way through Europe, Hitler took advantage of the wanton destruction and chaos, allowing his military to loot and take at their own discretion. The Nazi regime also took it upon themselves to transport every work of art back to Germany, where Hitler planned to amass the largest collection of art and artifacts in his own museum to showcase Germany's power to the world.

At the onset of World War II, Jewish families were systematically removed from their homes, and anything of value was documented and taken by the German military, marking the beginning of the anti-Semitic movement. The sheer volume of wealth stolen from the Jewish population makes it almost impossible to fully document. These families were forcibly removed from the homes they had been residing in for multiple generations, and their entire family history and ancestry stolen and never returned.

While thousands of works of art were stolen and destroyed during this period by the Nazi party, several of these works are highly regarded and well known today. Gustav Klimpt's *Woman in Gold* was stolen from a family who owned it since its creation. The painting was even re-named *Woman in Gold* from its original *Portrait of Adele Bloch-Blauer* to conceal its Jewish origin. Austria retained possession of this painting for a long period of time, before the daughter of the family who owned it took the Austrian government to court over its rightful ownership, inspiring the recent film *Woman in Gold*.[3]

The Ghent Altarpiece was another work stolen during World War II. Painted by Jan van Eyck and his brother Hubert van Eyck in 1482, this series of oil paintings has been the target of thieves, militaries, and admirers since its creation and throughout its lifespan. While it was taken by Germany during World War I, it was forced to be returned to its original location by the treaty of Versailles and was later targeted during World War II, once again by Germany—the very same country that had been forced to return it. The panels have been a target on thirteen separate occasions of theft, destruction, and censoring. They have been stolen by Napoleon and were one of the more notable artworks recovered by the Monuments Men during World War II.[4] Each of these instances, as well as a history of the work, artist, and its cultural

significance, is described by author Noah Charney in his book *Stealing the Mystic Lamb*.

World War II also marked the creation of military units dedicated to the tracking and recovery of these artworks and artifacts. A prime example of this type of unit is the "Monuments Men," as they were affectionately referred to. This unit was made up of professors, curators, and researchers who had dedicated their lives to studying these cultural marvels. They voluntarily chose to be trained by the military and to be deployed overseas in an effort to recover and return as much of the artwork as possible. The Russians, however, had a similar unit—with somewhat different goals in mind. Instead of returning the art and artifacts to the original owners, the Russian unit was instructed to bring as much art as possible back to Russia. Russia viewed these actions as restitution for the countless lives lost during the war.[5] While we briefly touch upon the men who scoured war-torn Europe in an effort to protect the world's treasures, we highly recommend reading the book *The Monuments Men* by Robert M. Edsel and Bret Witter to learn more about those who sacrificed so much in an effort to rescue and preserve the cultural identity and history of Western Europe.

Looting and art crimes were a staple of World War II and previous wars due to the nature of artwork and its cultural and emotional aspects. As the military forces moved through conquered areas, collecting artwork and artifacts seemed like an easy way to boost one's status when soldiers returned home. What are the injustices of stealing a work of art or an artifact in comparison to the horrors of war and the acts of violence men commit in order to survive? In the light of war, famous works of art can easily be stolen and looted, and the history of the work isn't questioned as sternly as it would be if it went missing during peacetime when thieves may face public scrutiny for attempting to sell an easily identifiable work of art.

Even Leonardo da Vinci's *Mona Lisa*, an iconic and well-known painting, has been stolen. As with many thefts from museums, it was an inside job. In this particular case, the culprit was a worker in the building, and the theft was perpetrated at night when security and staffing were minimal. On the night of August 21, 1911, a janitor by the name of Vincenzo Peruggia simply walked up to the painting, unscrewed the casing, and took it to a nearby service staircase. There he wrapped a

smock around the painting and then left the Louvre without anyone seeing him.[6]

Peruggia would keep the *Mona Lisa* in his apartment in Paris for two years. After that he took the painting with him to Italy, where he kept it hidden in his apartment in Florence. He was later reported by a gallery owner named Alfredo Geri. Once he was apprehended, Peruggia claimed that he was attempting to return the painting to its "rightful" home of Italy. Despite this statement, Geri stated that when he was approached by Peruggia, he clearly expected a reward for the painting.

A name that is infamous in the art world, especially to those interested in authenticating a legitimate history of a work, or provenance, is Giacomo Medici. Medici began dealing in arts and antiquities out of Rome, in the early 1960s. As of 1967, he became a major dealer of Italian antiquities to the United States, increasing his notoriety and infamy. While the sale of arts and antiquities, and being an art dealer, isn't illegal, the act of knowingly selling looted art and artifacts is, especially when the dealer is passing them off as legitimate works with a fake provenance (legal background).

In 1968 Medici opened his own art gallery in Rome and initiated trade to parties in Switzerland. This gallery remained open until 1978, when he entered into a partnership with Christian Boursaud, a Geneva resident. Using this connection, the two of them opened the Hydra Gallery in Geneva, Switzerland, in 1983. Medici, using his gallery, is now considered to be the highest transporter and seller of illicit art and material goods to London throughout the 1980s, in many cases selling more than seventy items at once. The sales continued to expand their reach until 1985 when the Getty Museum received fragments of the Onesimos kylix, a decorative drinking cup originating from Athens, Greece, in 500–490 B.C.E. The fragments themselves, valued at $100,000, were stolen from Italy and weren't returned until 1999.[7]

Near the end of the 1980s, Sotheby's in London, one of the most esteemed auction houses in the world, discovered that one of the items obtained from the Hydra Gallery was illicit in origin. Medici continued his sales without his partner, using front companies in order to hide the Hydra Gallery and himself as the dealer. Medici's clandestine actions remained hidden from the public eye until a sarcophagus was placed for auction by Sotheby's in 1995. This artifact was reported as stolen from a church in Rome, and the Italian Carabinieri took action. In connection

with Swiss law enforcement, Medici's storage house in Geneva was raided in September of 1995. The storage facility contained 3,800 different objects, more photographs of artwork and artifacts, and 35,000 sheets of paper documenting his business practices, his use of front companies, and how he falsified provenance histories of artifacts and art. Medici himself was arrested in Rome in July of 1997; he was later tried and convicted of a long list of charges, primarily the trafficking of thousands of artifacts. In 2004 he was sentenced to ten years in prison and fined 10 million Euros. The conviction and the court case led to a long process of returning the looted artifacts, now spread all over the world, to Italy and the nearby countries from which they were stolen.

In many cases art thefts are regarded as a victimless crime. The thieves rarely resort to violence and usually plan ahead in order to avoid confrontation. In the cinema, this is common practice; the devious thieves hatch elaborate schemes in order to avoid any type of violence, and the way they accomplish these goals is an art form in and of itself. Many believe that these items are completely covered by insurance, resulting in a full reimbursement for the item. Unfortunately this is not, in many cases, the reality; those willing to steal and commit other crimes are often willing to hurt and/or kill anyone who might stand in their way. Violence and crime often go hand in hand; as such no crime should be excluded from the possibility that it may end in violence and/or death.

On the night of July 24, 1969, at the Izmir Archaeology Museum in Istanbul, Turkey, over $5 million worth of art and artifacts were stolen. During the theft one of the night watchmen on duty was killed by unidentified thieves. The police arrested a German man on August 1. At the time of his arrest, 128 stolen items were found in his car. While it is rare that violence or murder occurs during art thefts, this is a perfect example of how any thief who is caught off guard or determined enough can resort to extreme measures.[8]

While many countries took a stance against art and cultural crimes, there were very few organized statements addressing the subject matter. Some countries took a stronger stance on the subject, such as Italy, which had—and still has—an incredibly rich cultural heritage. The issue is pressing to those countries with more to lose, particularly when there is no type of organized statements that could address all nations and all countries. If the nations of the world do not have a standard on

which to base their own practices, it's easy to see that with the cultural differences and dissimilarities placed on the value of art and heritage, the crimes will be handled in greatly different ways. The point is this: all countries have something to lose if there are no standard agreements. While one country may treat the crime harshly and prevent illicit work from entering that country, other countries may be more favorable, or at least less likely to prosecute the individuals transporting the works across borders.

The United Nations took an official stance on cultural crimes in 1970. The United Nations Educational, Scientific and Cultural Organization (UNESCO) issued an official statement regarding art and cultural crimes. As of 2011, this guideline for the prevention and awareness of cultural crimes has been ratified by 190 different nations. This convention applies to artifacts and artwork after the time of the convention being released; it does not apply retroactively, so any crimes committed prior to the convention being released are exempt.[9]

The main objective of the UNESCO convention on cultural crimes is to raise awareness on the subject of art and cultural crimes, as well as getting nations to commit to a list of security and prevention plans within their borders. Firstly, the countries adopting this policy must adhere to some protective measures, namely the adoption of codes of conduct regarding how cultural artifacts and items should be obtained, as well as the promotion of the nation's museums, libraries, and archives. Secondly, the nation must control the movement of cultural artifacts within its borders; in order to successfully accomplish this, the nation can use export certificates and will only accept artifacts with full certificates. Alongside this, it is important to ensure that art dealers are registered within the state. Thirdly, and lastly, the state that is adhering to this convention must return any illegally obtained cultural artifact from another country; these artifacts must be from a museum, religious institution, or public monument, and in order to demand the return, the state making the request must have adequate evidence supporting its claim.[10]

When the topic of art crime comes up, Western Europe is an obvious area for scholars and artists to turn to as a resource. However, some of the worst crimes take place in countries we would not expect. Looting, for example, is extremely common in third-world countries. The population's concern for their cultural icons is secondary due to the

horrific living conditions and the constant threat of war. The lack of official education on the subject is heightened when the population doesn't understand the importance of their history, their art, and their artifacts in relation to their cultural identity. The necessities of living overshadow the protection of their national culture. At that point the locals are more willing to trade artifacts for a small income in order to feed their families and themselves. Outside of the United States, and in many Western European countries, art crime isn't considered a major issue in their day-to-day lives when compared to violent crimes.

The largest art theft in Canadian history took place on September 4, 1972. The Montreal Museum of Fine Arts lost approximately $2 million worth of art. Armed thieves entered the museum and escaped with jewelry, figurines, and eighteen paintings. Among the paintings stolen were works by Delacroix, Gainsborough, and a Rembrandt landscape. This theft, similar to the Isabella Stewart Gardner theft, is still unsolved today. The Rembrandt alone is valued at $1 million. [11]

Some of the more intriguing crimes in history consist of thefts, looting, or large-scale destruction of artwork. Forgeries, however, are an often overlooked aspect of art crime. Ironically, it is an art form in and of itself when forgers are capable of creating works of art that deceive some of the most renowned art experts. In many cases the forgers themselves use the act of forging artwork as a means of touting their skills against those same educated professionals in the art world.

One of the most infamous forgers in history began his career in 1989 and continued until he was discovered by law enforcement in 2006. Shaun Greenhalgh created a family of forgers by using his brother and his parents. His works during this stretch of time were successfully passed off as originals and sold to a variety of venues, including auction houses, museums, and private buyers. Remarkably through his forgeries Greenhalgh made over £1 million. During the trial there were forty-four different forged works discovered, and at least 120 different works are known to have been created and sold by Greenhalgh. It is assumed that there are far more forged works in circulation that have yet to be discovered.

The forged works were so well done that the museum curators would examine the works carefully and compare these works to their provenance histories, and come to the conclusion that they were legitimate artifacts. The family was eventually caught attempting to sell an

Assyrian relief carving. Upon closer inspection there appeared to be misspellings in the cuneiform writing. At this point the provenance of the work was investigated, and it was discovered that the same provenance had been used before by the same family. Greenhalgh had become overconfident and reused a previous work's history in order to make another sale. Shaun Greenhalgh was convicted for his crimes in 2008 and would spend the next four years and eight months in prison. [12]

While the Greenhalgh family did make a profit off of the forged works, it appears they did not commit forgery strictly for the money. As a matter of fact, it seemed that the monetary value of the forged works was not a motivating factor for them. Theories abound of what motivated the family to spend so much time and effort forging famous works and artifacts. The police speculated that possibly Shaun was so upset that his own artistic talents were not properly recognized that he turned to selling and creating famous works. By selling these works to museums and private owners, he gained a sense of entitlement and recognition knowing that his artistic works were being displayed under the guise of a famous work. In a way he was "shaming" or "showing up" the art world. Because his individual works were rejected, he created imitations of famous works that would be valued for being such perfect forgeries that even the art experts could not determine if they were indeed fakes.

While the United States is not mentioned as frequently when discussing art crimes, especially when discussing art thefts, Boston, Massachusetts, is the site of the largest art theft in history. Even more disturbing is the fact that while it took place in 1990, those who stole the works are still at large, and none of the stolen works has been recovered. The price tag alone amounts to over $500 million worth of art stolen; among the items stolen was a Vermeer, Rembrandt's only known seascape, and works from Degas and Flinck. This being such a large-scale theft, and because it is still unresolved, it leaves art histories, investigators, and scholars fascinated.

During the night of March 18, 1990, two men dressed as police officers approached the building. The two night security guards questioned the officers and were told that the officers were responding to an alarm on the premise. Once the officers were allowed in, the guards were immediately subdued and left tied and bound in the basement. For the next hour and twenty-one minutes, the two thieves, still dressed

as officers with fake moustaches, took their time moving from one room to the next taking the objects and artwork that they wanted.

No alarms were ever tripped, and the motion detector readouts were taken by the thieves when they left; law enforcement, however, was able to obtain the backup archives. The readouts told them how long the thieves had stayed in each room, how many times they went from room to room, and the time of day they moved throughout the building. After the two thieves left with the stolen items, they disappeared into the night. Law enforcement to this day is still attempting to locate and identify those responsible. On several occasions police believed they were closing in, only to lose the lead. Retired FBI agent Robert K. Wittman, in his book *Priceless*, goes into detail describing one such occasion. He was undercover and closing in on the stolen Vermeer when he lost the opportunity before he could catch the individual making the sale. [13]

When the general public thinks about art crimes, they imagine thefts of artworks or artifacts. The all-encompassing term "art crime," however, also includes unique musical instruments. Some of the finest instruments made are indeed works of art and are renowned for their beauty as well as their sound in musical art forms. Some of the rarer instruments have an exorbitant value and are sought after due to their high price and prestige.

In October of 1995 a violin was stolen from renowned violinist Erika Morini. The violin was a rare, highly valued item known as a Stradivarius. The Stradivarius was made in 1727 by Antonio Stradivari, whose instruments, some of the most famous in the world, are highly regarded and valued for the remarkable craftsmanship that went into their making as well as their spectacular acoustics. The violin was being stored in Morini's locked closet in her apartment. At the time of the theft Morini was ninety-one. Tragically, she died a month later while she was being hospitalized. She was never told of the theft nor has it been solved. Today, the violin would be estimated at $3 million on an open market. [14]

It is rare that art thefts, or heists in general, come off as well planned and theatrical as they appear in the cinema. This, however, is not the case for the theft from the Stockholm National Museum. In this instance, the theft appeared to be something out of a movie. On the evening of December 22, 2000, three thieves entered the museum shortly after dousing several vehicles outside in lighter fluid and lighting

them ablaze, and scattering tire spikes in the front parking area and the roads leading to the museum. One of the thieves held those within the museum at gunpoint, screaming for them to get down as the other two thieves ran throughout the museum grabbing paintings.

From the reports of the theft, the two thieves collecting the artwork selected specific ones and knew exactly where to go, giving investigators evidence that these thieves had selected which works to take prior to the robbery. Among the works stolen were two Renoir paintings and a Rembrandt. After stealing the paintings, the three thieves left the museum, running to the river just around the corner from the front entrance. There an associate was ready for them in a speedboat that they used to get away. While law enforcement personnel were delayed by the spikes the thieves laid across the roadways, they were also delayed by carefully planned explosions and fires by the thieves at the opposite ends of the city, drawing them as far away as possible from the museum. It took years before the authorities managed to collect all of the stolen paintings. In today's legitimate market, one of the stolen paintings alone would carry a $40 million price tag.[15]

The United States has only become a target of the art crime category in recent years, probably due primarily to the lack of a long and diverse cultural history. There have, however, been remarkable strides toward the prevention of art and art-related crimes in the United States. While the United States does not have the heritage and cultural history of Western Europe, it is the primary market for all legal and illicit artwork in the world. Many ignore the history of the United States and forget how much the artists' contributions add to that history, giving us a perspective otherwise unseen.

A theft from a West Hollywood, California, gallery in 2002 is among the Federal Bureau of Investigation's (FBI) list of unsolved art crimes. Two murals painted by Maxfield Parrish between 1912 and 1916, measuring sixty-two by seventy-two inches, were stolen. These murals were part of a seven-piece set for the founder of the Whitney Museum of American Art, Gertrude Vanderbilt Whitney. The estimated value of the missing works is $4 million. When the FBI added the murals to the top-ten list of art crimes in 2005, Deborah Pierce, the deputy assistant director at the time, was quoted as saying, "These lost masterworks are of extreme artistic importance, and their loss goes past a dollar amount. We've also lost a piece of our American cultural heritage." This further

illustrates the importance of art crime and the damage it can have on American culture.[16]

During times of war, it is easy for anyone to take advantage of the chaos and confusion, such as riots and civil strife, in order to steal and loot whatever they desire. If there is a riot or protest occurring outside of a museum or a home that thieves wish to rob, the security that would normally be watching the interior would be focused on the hectic cacophony occurring on the exterior. Even with the extra law enforcement that is stationed during times of unrest, the focus is almost always centered on the crowd causing the disturbance, and less on the businesses nearby. Law enforcement's attention might be fixated elsewhere, however, should they be required to follow and dissuade the crowd of rioters.

More recently, many of us remember the riots occurring within Egypt in 2011. The Arab Spring, as it is now referred to, provided a cover for another art theft and looting. Originally the Minister of Antiquities in Egypt, Zahi Hawass, announced that while the Cairo museum had been breached, to his knowledge nothing was missing. Two groups had entered the museum during January of 2011, using the riots as a distraction. The first group entered through the main doors; while breaking a few display cases, they focused their attention on the gift shop and were later apprehended in the kitchen cooking food for themselves. The second group, however, had planned their criminal act. It is believed that the second group went in through the skylights; mysteriously all the cameras were turned off at the time. It is believed that the looters had a list of the high-priced items that they could sell quickly and safely; however, at this time it is unknown what was taken or where any of the stolen goods are now. Many of the statues and displays were damaged during this period, but they have long since been repaired.[17]

Art and cultural crime is not new to the world. With many types of art and culture, the subject matter is lusted and fought over by those of influence. Crimes against the arts occur for a variety of reasons. The large array of motivations, however, almost always funnel down to the most basic: human desire. These crimes are not anything new or recent, but according to the United Nations, they have increased in prevalence, particularly within the last century.[18]

While these crimes aren't as horrifying or detrimental as the pace of wartime destruction and looting of art and artifacts, the deprivation of

these heritage icons is still the same. Whether it is the literal destruction of art, the theft of it, or the act of passing one's own work off as that of a great artist, it still deprives the world and one's community of a valuable source of information and history.

In order to protect and respect our art and culture, we need to view history as our own. If we view our history and our cultural heritage as our own, we embrace the work and the meaning of it. Through our history we view our faults and failings, our suffering and our own greatness, and through this we can see examples of how we can better ourselves. We can also see how we have excelled and interpret what makes us who we are. Both our failings and our successes determine who we are. That history defines our culture and our heritage; it reminds us of how we became the society that we are today. The dollar value we may place on that history is nothing in comparison to what we will lose if we do not make that history a priority in our lives and in our society as a whole.

5

CULTURAL DIFFERENCES BETWEEN THE UNITED STATES AND EUROPE

How It Affects Art Crime

The United States has such a wide cultural forum that determining what we consider to be American art and culture conjures up a vast array of choices. Art and culture are measured by a broad standard depending on the individual or group. While there are numerous museums, monuments, and entertainment venues, American culture also includes Hollywood, television, Broadway, local theater, and music that varies from rock and roll, country, pop, blues, jazz, hip hop, and rap, to name the most current and popular. There are major cultural differences within the United States, and the cultural differences between the United States and Europe cannot be overstated. These disparities affect the values and attention the United States places on art crime. Historical reasons for this difference include the young age of the United States as a country in comparison to those in Europe and Asia. The separation from Great Britain, slavery, the Civil War, and subsequent military encounters, and finally U.S. democracy as a capitalist nation— all define an identity dissimilar to that of Europe. The implication of American values weighs heavily on how citizens identify or stigmatize art. It is also important to note the unbalanced representation of race in art and culture in the United States.

Due to their cultural perceptions, we believe that the citizens of the United States are not as concerned with art theft. For example, Cultural

Theory maintains that there is a relationship between people and their surroundings.[1] The various themes Americans encounter in our environment have a direct and substantial bearing on how we relate to people and our surroundings. Cultural Theory is very disparate or different and often includes many elements of society. The definition of culture is taken from Marvin Harris, who defines culture as socially learned in societies, focusing on all interactions of life, including acceptable behavior, as well as the general mindset of society. In order to clarify, we are considering the themes or various elements that influence culture and art to include history, race, architecture, various forms of entertainment, technology, economy, demographics including high and low culture as well as geography. Each of these elements is used to identify the aspects of American culture that influence artistic values and the subsequent position on American art theft.

It would be interesting to ask children and young people in the U.S.A. what art and culture mean to them. Would the arts be identified as high culture—including paintings, sculptures, and other artifacts—or would many youths be inclined to state lower culture offerings such as Disney World, Hollywood, MGM studios, pop music, or You Tube sensations? What would a European believe to be American arts and culture? Would they offer a similar list including Los Angeles and New York as the prime cultural cities, or perhaps cowboys and movie stars? Who are America's artists and famous architects, and what are their most famous works? How many Americans can name at least two?

American culture is unique because it is a relatively new country, aside from the Indigenous inhabitants; U.S. history is measured in hundreds of years compared to Europe, Asia, and the Middle East, whose art and culture are thousands of years old. Europeans are cognizant of their art and architecture as it is so prevalent; and their citizens, from schooling and visitations to local museums and galleries, recognize their famous artists. The United States began as a colony of Great Britain and as such was embroiled in colonization with English as the predominant language and bourgeois attitudes toward culture and art. Although America became independent in 1776, it followed the ideals of Great Britain in terms of race and culture. There was an attempt to displace the Indigenous Nations of America, slavery was endorsed, and the concept of literature and fine art remained a European stronghold. America itself is built on war; the creation of the country literally arose from

revolution and the subsequent separation from England. The major motivation directly following the separation was to distance America from English influence and European ideals. With the move away from anything British, the United States attempted to renew itself by focusing on its own cultural heritage and history.

The American Revolution was politically and economically motivated and emerged during a time of a growing middle class who adhered to the philosophy of the "unalienable rights to life, liberty, and property"—a phrase openly borrowed from English philosopher John Locke's *Second Treatise on Civil Government* (1690).[2] The U.S. Constitution, adopted in 1787, established the growth of a capitalist economy with an open common market without tariffs or taxes from the East Coast to the Mississippi. The country's economy grew with migration moving westward and the building of the railways and river transportation. The United States has numerous natural resources, minerals, and agricultural products—gold, cotton, wheat, and tobacco—that moved the country's economy forward. Although the Industrial Revolution began in England in the eighteenth and nineteenth centuries, it did not begin in the United States until the mid-nineteenth century. The northeastern portion of the country produced manufactured goods, and the south remained rural, relying on the north for their manufacturing and slavery for their agrarian economy. A bloody fight between the colonies and Great Britain followed by the American Civil War less than a century later from 1860 to 1865 fortified the attitudes of this relatively new nation. Following the Civil War slavery was abolished and the northern industrialists dominated the American economic system. This is a fascinating period of American history and it is no wonder that Americans cherish artifacts from the American Revolution and the Civil War. Memorabilia from this era is very popular in the United States, with families passing their guns, swords, and so on down from one generation to the next. American collectors and enthusiasts keep this history of war current by recreating Civil War battles and maintaining museums dedicated to this period.

The end of the Civil War defined the political and economic status of the United States at that time, but it also left a country torn, with families having fought against one another, women widowed, children left orphaned, and devastation of the psyche of the nation that few could imagine. Recently a very interesting study was conducted to de-

termine if the soldiers from the Civil War suffered from post-traumatic stress disorder (PTSD) as do our soldiers today. The National Bureau of Economic Research, partially funded by the National Institute of Aging, researched a project called the Early Indicators of Later Work Levels, Disease, and Death Project. The project endeavored to identify the risk of illness among Civil War veterans following the Civil War. They examined data from the federal project utilizing digitized medical records of veterans of the American Civil War. They examined the records of military servicemen and pension files against surgeons' reports and medical examinations. Their findings are very interesting because they show an increase in cardiac issues, gastrointestinal problems, and mental illness among the veterans, and these ailments followed them throughout their lives. What is tragic is that 45 percent of the men exhibited mental health problems that we today recognize as PTSD. The most severely affected were the young men who entered the war underage, enlisting before they were seventeen years of age.[3]

Although many of the veterans from World War I and World War II, as well as those from the Korean War, must have suffered from PTSD, it was not until the end of the twentieth century—after the Vietnam war, Falklands, Gulf War, Afghanistan, Iraq, Pakistan, and ISIL—that PTSD was recognized as a mental health condition resulting from the effects of war. These effects have had an impact on American culture regardless of the fact that the war took place elsewhere. The soldiers returning home brought the war back with them to be played out at home with an impact on the families and communities involved. The lives lost in wars fought both on and off U.S. soil are a source of American pride and military might that is reflected in the nation's statues and monuments. These include the statue of Zebulon Baird Vance, the Confederate military officer, located at the State Capitol in Raleigh, North Carolina; the numerous statues at and around the Fort Bragg military base in North Carolina; the Iwo Jima Memorial in Arlington, Virginia; the Korean War Veteran's Memorial; the beautiful Vietnam Veteran's Memorial; the Washington Monument; the Lincoln Memorial in Washington, DC; the USS Arizona Memorial in Hawaii; and the General William Tecumseh Sherman Memorial located in Manhattan's Grand Army Plaza in New York City. Any amount of travel will find monuments and statues around the world honoring their heroes and their dead. The United States is not alone in erecting statues and me-

morials to those who have offered the ultimate sacrifice, a tradition that began from the earliest history of man and became increasingly popular after World War I. War memorials and statues are found in every state in the nation.

The military in the United States is central to many of the core cultural values of the country. The origin of the nation itself is one of war arising from the American Revolution. What followed was the growth in the military with a string of Indian and territorial wars too numerous to mention. The U.S. Army values are officially listed as "Loyalty, Duty, Respect, Selfless Service, Integrity, Honor and Personal Courage."[4] The U.S. Army website (www.goarmy.com) states that these values originate in the central beliefs of American culture, central to what it means to be an American. The American character is one born of difficult sacrifices made throughout its history. It is noteworthy that the American ambassadors represent the United States in countries throughout the world; internationally, the army is the face of the American nation.

It is not surprising then that globally America is recognized for its military might, often called upon or willing to intervene of its own volition in countries around the world. As with the many wars Americans have participated in, most are incited by political and economic justifications. Although the United States originated as a capitalist economy following the revolution, it is now considered a mixed economy. The American economic system relies on entrepreneurs, natural resources, technology, and a qualified labor force.[5] The United States also relies heavily on resources from other nations; trade and cheap labor are required to meet the appetites of American consumers. The methods engaged by America to attain the demands of the American lifestyle have been criticized as exploiting developing countries or American culture dominating and endangering the cultures of the nations where the United States is present. The military may be the face of America to other countries, but the military and economic strategies reflect the American embodiment of their culture. The concepts of freedom, the right to bear arms, and the history of the nation's wars are the essence of Americans' perceptions and cultural ideals. This perception embodies the architecture of the nation when one looks at the number of national monuments celebrating the accomplishments of America. Consider the Statue of Liberty, a gift from France, welcoming

immigrants to their new home, promising freedom and democracy; it is the embodiment of the freedoms Americans cherish. There is also South Dakota's Mount Rushmore, an incredible feat for the time and the brainchild of Doane Robinson; the Hoover Dam in Arizona; the Space Needle in Seattle, Washington; the skyscrapers of New York (the Empire State Building, in particular), and the 9/11 Ground Zero Memorial. Americans are ready to fight for the love of God, their freedoms, their rights under the Constitution, and against any attack against these principles or the memorials that represent these basic beliefs. The capitalist economy and military affect the cultural values of a nation, which in turn influence the architecture and artistic appreciation and values of what is important to its citizens.

Thomas Jefferson stated that America needed its own architectural style in order to differentiate itself and its culture while separating itself from Europe,[6] an ideological notion that over time developed as each city and area of the country produced its own architectural American style. American architecture is a combination of styles introduced by settlers who borrowed designs from their native countries based on their understanding of construction and architecture and incorporated them into their new homeland. Gothic style, representative of churches rising up skyward—complete with gargoyles—influenced the houses and farming structures of early America. To a great degree, Spanish colonial, with its clay-tiled roofs and floors, are found in Florida, Texas, Arizona, and New Mexico, providing Spanish settlers with the building materials easily found in these areas. English colonial homes with their boxy style, steep roofs, small windows, and large fireplaces were built of wood, and because of this, few remain. Dutch colonial style is specific to New York, New Jersey, and Pennsylvania—generally a stone-and-brick, one-and-a-half story building with a steep gabled roof over an open front porch. The Swedish Colonial started in Pennsylvania with the earliest Swedish settlers building log cabins along the lower Delaware. The log cabin was an expedient and efficient means of building a home and was soon adopted by other immigrants needing to find a cheap and sturdy home in a short period of time. The French in Louisiana and Mississippi were influenced by the slaves from Africa, who taught them to build porches encircling the house for air circulation and raised off the ground to deal with the wet and humid conditions. Southern homes in the New World borrowed from the English Geor-

gian style brought to England from Italy. The Georgian homes were two-story structures built from wood or brick and characterized by symmetry around the central entrance. They exhibit pedimented or triangular dormers and windows with quoins on the corners of the building, described as being made of brick or stone that differs from the rest of the wall masonry in size, color, and texture. The quoins, of brick or stone, which jut out along the sides of buildings, were used for strength and aesthetic purposes. The most famous Georgian homes are those of Southern plantation owners built in the eighteenth century that typically display huge white columns and large front entrances with open porches.

One of America's most famous architects from the 1800s is Alexander J. Davis. He initially specialized in the Greek Revival style for capitols and residences.[7] By the middle of the nineteenth century, Davis became the leading architect in country houses. He also collaborated with landscapers to surround his architectural designs to create a pleasing atmosphere in harmony with the country home.

The buildings in America up to the late nineteenth and early twentieth centuries were designed to mimic early architectural styles with various European traditions such as the Gothic Revival and Italianate. The Gothic revival, made with stone and brick, imitated the castles and churches of Europe with Gothic cottages decorated with gingerbread trim and scrolled ornaments. This period was the last to focus on past forms of European architectural periods. By the end of the nineteenth century, America celebrated its centennial as a country, bringing with it a sense of self-esteem. Americans now looked back on the period as the "Eclectic Movement." Inspiration for American architecture at this time was derived from the buildings of early America. The United States was now making the architectural statement Thomas Jefferson had hoped for by individuating and separating itself from Europe.[8]

At the turn of the twentieth century, the new American ideal was that everyone should have a home. The Arts and Craft and Prairie School homes were meant to use local materials—there was an abundance of wood and stone and plenty of land. This "Modernist Architecture" was meant to be functional using contemporary building techniques and building materials of concrete, glass, steel, and iron. The Arts and Craft movement that began in Europe centered on designs based on nature and influenced American architects like Frank Lloyd

Wright. Wright, one of America's better-known architects, favored the "Prairie School" for residential homes with wide rooms and ample light. His accomplishments include both large and small homes, churches, hotels, museums, and skyscrapers. The Arts and Crafts and Prairie School homes were expensive to build because of the craftsmanship, putting them out of reach for many. In answer to this dilemma, small cottages or bungalows—with a combination of outside influences ranging from craftsman style to colonial, Spanish, Western, or Chicago style—were built. These homes, meant to be functional, were generally one to one-and-a-half stories with an open floor plan, a large porch, and a front door entering into the living room. The Modernist Architecture was a new concept that left behind the old colonial beliefs. The bungalow replaced the modernist style, adapting to the Art Nouveau style both inside and out, adding amenities such as refrigerators. People began decorating their homes with wallpaper, stained glass and ceramics, and fabric until the Great Depression, when lives became more difficult and rigid due to the economy.

Technical engineering innovation in the United States during the second half of the nineteenth century was noteworthy with the building of the Brooklyn Bridge, started by John Augustus Roebling and completed by his son Washington Roebling. The engineering advancements led the United States to create inspirational buildings with the use of cast iron, steel, and reinforced concrete. By the end of the nineteenth and beginning of the twentieth centuries, America began using steel-frame construction in high-rise architecture in Chicago and New York, stemming from the Chicago School of Architecture, the New York School of Sky Scraper Architecture, and the Second Chicago School of Architecture. The two cities were growing rapidly and land was at a premium while steel prices were reasonable, so it made sense to build upward. Numerous techniques were used to build high-rise developments in both cities; however, New York become the most famous around the world for its skyscrapers. The Art Deco style of skyscrapers originating out of France and using geometric forms was popular from the 1920s until World War II. The most famous art deco skyscrapers are the Empire State Building, the Chrysler Building, and the old AIG building known as 70 Pine Street, all located in New York City. The Modernist architecture from the 1940s to the 1960s claimed simple functional lines and lacked the older ornamental designs. The skyscrap-

ers of the Modernist period used modern building techniques, functional floor plans, and materials of concrete, steel, and glass. The buildings held a presence of space and beauty, such as the Seagram building in New York, decorated with straight lines that lift the eye upward, giving the building a feeling of expanse and culmination of height. During the 1950s, there was a move toward decorative formalism, where architects used structural designs as a form of decorative expression. Examples of this style include Frank Lloyd Wright's Guggenheim Museum and the former Twin Towers of the World Trade Center in New York.

The Postmodernist era brought the idea of "anything goes," adding art and function to architecture. The architecture combines blends of traditional with contemporary styles, exaggerated or abstract details, and materials from any source. The designs are humorous and contradictory. In some cases, the buildings have past architectural designs such as Greek columns or classical arches mixed with the postmodernist designs. In addition, there was a Deconstructivism postmodernism from the 1980s to 2010 that does not lend itself to traditional proportions but rather slanted and jutting walls that appear as though the entire building was pushed and twisted, or the walls melted from a powerful heatwave. Postmodernist style moved away from the functionalism and traditionalism of the Modern Era, considering it too dull.

Postmodernism is said to have begun in the United States in 1972 with the demolition of Minoru Yamasaki's award-winning Pruitt-Igoe housing project in St. Louis, Missouri, which was built in 1955. The project was a stark concrete building that encountered numerous problems. In response to the lack of housing following World War I, there were a series of low-cost social housing projects in many urban areas, many having the general appearance of large-scale apartment blocks. Nationally there were a number of functional housing projects built in a similar fashion but it was the Pruitt-Igoe housing project, with all of the social problems associated with the complex, that stymied future modern designs when it was torn down seventeen years after it was built.[9]

The shortened historical overview of American architectural design is fascinating; however, it does not specify how Americans identify with the architecture of the nation as a whole and what it says about its culture. Ultimately buildings and monuments are distinguishable to cities across the United States, in particular the skyscrapers of Chicago

and New York City. Northern and southern states have a visual appeal that differs substantially from the east and west coasts as well as Central America.

The cultural heritage of Europe is evident in the architecture and age of its buildings. It is not uncommon to view streets and buildings that are hundreds and, in the cases of remains of roads and buildings, thousands of years old. A country's culture is not only represented in its art but in its architecture as a display of its attitudes, a concrete demonstration of what is valued in that society. Initially, religious teachings were expressed in the architecture and art in churches for public display, while large estates, over time, allowed the public access to the art and architecture within, as artistic symbols of their governance. The estates claimed the identity of the country. It was the revolutionary movements that destroyed monuments and paintings of toppled rulers.[10] While the United States was not faced with the prospect of destroying previous monuments and paintings to rebuild the new country, it was faced with identifying what is American.

The history of America recognizes the European influence in our architecture, art, and literature, but acknowledging the many other cultures of this nation has not come easy for many groups and their influence is often found only in geographical locales where these groups are most prevalent. America experienced colonial immigration beginning with slavery until after World War II and the fact that immigrants who initially came to America were expected to assimilate by becoming part of the melting pot may account for this phenomenon. American culture is not inclusive, however, when it comes to art forms from African American, Asian, Spanish, and Native Americans, to name a few. The non-white populations were not as valued, remaining as the working class or unemployed.[11] The unfortunate aspect of this circumstance is the exclusion of the original native inhabitants and black individuals who were brought to America as slaves, as well as non-white immigrants who offer a blend of unique artistic works that are only recognized by a few. America's literature and art came directly from Europe; it did not have the history or culture of Africa, Asia, or Europe; the Native American culture was neither valued nor understood; and the artistic endeavors of the black population were denied until the late nineteenth century.

The Harlem Renaissance was the African American cultural revolution centered in Harlem, New York City. After World War I, there was an openness and willingness to try new things, and the black population moved away from the rural south and "Jim Crow" laws to work in industrialized cities in the north. The Harlem Renaissance took place from the mid to late 1920s to the 1930s, declining after the Great Depression. The "New Negro" movement generated a Negro culture of literary works, art, music, dance, and theater. Numerous artists influenced African American culture at this time—Alain Locke, a distinguished scholar and philosopher, who regarded race as a social and cultural function; and Marcus Garvey, who began the Universal Negro Improvement Movement. During this key period, the Harlem Renaissance elevated black pride through the use of intellect and talent. African Americans, using artistic talents, challenged racial stereotypes and helped promote racial integration into America and around the world. This philosophical movement was the core of the Civil Rights movements with writers challenging political ideologies regarding race. The Harlem Renaissance advanced African American literary and artistic endeavors bringing encouragement and pride to a new generation.

In 1899 the Philadelphia Museum of Art was the first American museum to purchase a work by Ossawa Tanner, an African American artist. The traditional painting, titled *The Annunciation*, is a religious painting depicting the visit of angel Gabriel to Mary.[12] Unlike other paintings of the time, the angel Gabriel was portrayed as a shaft of light while Mary was dressed in Middle Eastern peasant clothing and was not painted with a halo. Faith Ringgold is a more modern, talented, and internationally acclaimed black artist. She is an educator, painter, writer, and mixed media sculptor. Her murals, paintings, and quilt making are located and exhibited in New York, California, and Florida, as well as around the world in public spaces, museums, art galleries, and private collections. Ringgold is also a successful award-winning writer and illustrator of children's stories. It has taken years for black artists to gain acknowledgment, yet they still do not have the respect they deserve from mainstream America.[13]

Other races in America also suffered racism and disparagement. Asian immigrants arrived in San Francisco along with immigrants from other countries to get rich in the gold rush in the early 1800s. The Asian gold miners expected to strike it rich and return to China as wealthy

men. In time the gold rush crushed the dreams of many newcomers to America, but the Chinese were hardworking and willing to do the most menial work. They worked in the mines, as domestics, as cooks in restaurants, and did so for less pay than the other immigrants. It was the Chinese laborers who were responsible for the majority of the dangerous and backbreaking work required to build the railroads in California and the American Transnational Railroad. They experienced racism because of their skin color and different facial features, and the queue, or long pigtail, that hung down their back; they were judged, as well, by the use of opium, the food they ate, and their living arrangements—they lived in groups as bachelors rather than in the family unit cherished by American society.[14] The Chinese were admired for their hard work and acceptance of modest wages; however, throughout America's history, whenever jobs are few or the economy is in a downturn, racism becomes more prevalent. Along with racism came fear mongering, with many believing the Chinese were secretly planning on taking over the government. When the Japanese attacked Pearl Harbor at the beginning of World War II, Asian Americans were interned by the government and had their homes and businesses confiscated. The racism continued and may be seen in media illustrations of Asians with exaggerated slanted eyes and bucktoothed, appearing dim-witted and sinister. Negative stereotypical images are used against all races in America by white society. White superiority was further entrenched in the late nineteenth century and up to the middle of the twentieth century with Darwin's Theory of Evolution. Caucasians erroneously believed the theory placed them at the top of the hierarchy.

It was in the 1920s that a young Japanese man named Yasuo Kuniyoshi immigrated to New York to study art and never left. His work may be found in the Smithsonian American Art Museum in Washington, DC, museums in Japan, and private collections. Yasuo Kuniyoshi was a modernist artist whose artistic talent was often overlooked due to his race. Unfortunately, due to the racist attitudes of America at the time, many of his works are no longer in the United States. The Japanese government and private collectors purchased them after his death in 1953. During the 1940s and 1950s, at a time when Kuniyoshi should have been thriving, McCarthyism and anti-communist sentiment detained the careers of many modern artists. American artistic culture

became stagnated. Modern art was considered un-American because it was ugly and did not portray realistic pictures of Americans.[15]

There are Asian museums across America, and a number of these venues focus on a particular culture within Asia such as Korean, Chinese, Japanese, and Hmong. There is the Asian Art Museum–Chong-Moon Lee Center for Asian Art and Culture in San Francisco, California, which is devoted to Asian art with a strong emphasis on Korean art. In Los Angeles, California, there is the Japanese American National Museum and in New York the Asia Society and Museum. The most American of the Asian American museums is assuredly the Wing Luke Asian Museum in Seattle, Washington. This museum is specific to that geographical community, favoring art linked to the community and history of the area rather than traditional Asian art and vases found in other museums.

Racism has hindered the accomplishments and prominence of many artists in America. Unfairly judged by their skin color or racial artistic preferences, these artists' works were barred from public view in museums and denied acceptance by the general public. In addition to race, the acceptance of American art has also been blocked because of religion. Spanish art brought to America was entwined with Roman Catholicism that did not meet with the conventional Protestant ideal of America. Spanish art and religion further influenced the Aztec, Inca, and Maya peoples of South America who worked with the Spanish on artistic endeavors that differ from the development of art in the United States.[16] Whether it is Spanish, Latino, or Mexican art, the popularity of such artwork is found in areas of the United States with predominantly Spanish influence such as Florida, California, Arizona, and Texas. Latino and Mexican art is easily found in these states but not so in mainstream museums throughout America. A strong proponent of Latino art, Maria Teresa Avila criticizes the Smithsonian museum for largely excluding Latino artists, arguing that the history of American colonialism and powerful economic interests continue to negatively downplay Latino contributions. Avila gives credit to the traveling exhibits of Latino art but questions why the documentation beside the art offers the artist's name but nothing to educate the American public on the history and relevance of the art itself. There are recognizable Mexican and Spanish artists such as Fernando Botero, Frida Kahlo, Pablo Picasso, or Diego Riviera, but where are the American Latino and Mexican artists

that should be familiar to all Americans? Considering the Latino population in the United States, one would think the American museums would showcase more American Latino exhibits for artists such as Frank Romero, the muralist from Los Angeles; Jose Bedia, the acclaimed artist from Miami; and Soraida Martinez from New York, to name but a few.[17]

American colonialism exploited African Americans brought to the United States as slaves, the Chinese as cheap labor, and the Latino and Mexican for their land and cheap labor; but it was the Native American who suffered most egregiously. The decimation of Native American Indians by disease, war, starvation, murder, and theft of pride took the greatest toll. Since Europeans first set foot on the Americas, Native Americans have lost tribes, traditions, ceremonial objects, knowledge of survival and spirituality garnered through the ages, languages, art, dance, pottery, beadwork, songs, and bloodlines.

Ancestry is often difficult to confirm, as records were not kept until the nineteenth century; however, the tribes define the membership within their communities, and this is not entirely based on bloodline. There are many who claim to be part American Indian saying they are an eighth or one quarter with a strong sense of pride. Boasting of one's American Indian bloodline, however, is a relatively new phenomenon. Up until the 1970s, American Indian children were taken from their parents and housed in residential schools, after which they were placed into white families by the government in an effort to integrate an entire population into white society.

Growing up American Indian is difficult. One is faced with racism, poor living conditions, lack of opportunity on reserves, limited education, and, with the passing of each elder, the deterioration and potential extinction of one's culture. In the past, Americans Indians who could pass as white often did, remaining quiet about their lineage in order to hold a job or to simply to make their lives bearable.

American Indians were considered pagans, a nation of people that needed to be guided and saved by white society. White society did not consider American Indians as a culture that had anything to offer other than "Wild West Show" entertainment or—as erroneously portrayed in movies and generally by white actors—as unintelligent people with a vocabulary of grunts who never won in battle. It is impossible to determine what American society has lost as a whole with the exclusion of

Native American culture in America. Thanks to George Gustav Heye the first museum of the American Indian was born in New York City in 1916. The Heye collection began in 1897 and expanded to archaeological findings around the world until his death in 1957. The museum continued to grow but not without financial and administrative difficulties until the transfer in 1989 to the Smithsonian Institute. The National Museum of the American Indian now partners with the Native Americans leading the collection of materials to coincide with consultations with community representatives. A few additional museums centered on American Indian art include the Museum of Contemporary Native Arts in Santa Fe, New Mexico; the Millicent Rogers Museum in Taos, New Mexico; and the Heard Museum in Phoenix, Arizona.[18]

Representations by the different groups that make up America accurately portray American culture. The art and culture of America is not based on one race—*all races combined* determine what American culture is in the United States. The low culture entertainment of Hollywood or Disney is definitely a part of the American culture, but representation of American history with actors and animated characters that offer a cotton-candy or skewed portrayal of the history of America is misleading and dangerous. What makes American art high culture is the raw truth it exhibits through representations of oppression or beauty whether it is traditional or modern, in any form or in any medium— high cultural art that withstands the ages, that will be present and meaningful a thousand years from today.

Let us return to the question of American culture and how it is best described. The American military might, throughout history and presence around the world, is defined by the military as central to American culture and what it means to be American. We accept this, and will not argue with the U.S. military. Architecture in the United States did not come into its own until the late nineteenth and early twentieth centuries. What is particular to U.S. culture is the vast highways and freeways that lead to suburban box-like homes. The major cities have recognizable skyscrapers, but few Americans would be able to identify one or two famous American architects. The vast geography of the United States accounts for styles of homes that differ from east to west and north to south, built for those particular climates and densities of populations. What of the famous American artists? What art is central to American's sense of being? The majority of Americans are not as con-

cerned with art and art theft as people in Europe or other countries; because it is not important to Americans, it has little relevance in their day-to-day lives. The United States is a country with a strong military; it is wealthy, has abundant natural resources, and boasts a labor force with a strong work ethic capable of maintaining the economy. As a capitalist nation with one of the highest standards of living in the world, and a people who consider themselves free to do what they want, Americans also expect to be able to purchase and obtain what they can afford. This attitude includes purchasing art and artifacts that are affordable and attainable, whether procured legally or illegally from another country. Unfortunately, Nicolas Cage purchased a rare stolen dinosaur skull for $276,000 from the I.M Chait gallery in Beverly Hills in March 2007. The gallery sold the skull with a certificate of authenticity to the actor, who purchased it from convicted paleontologist Eric Prokopi of Florida. The U.S. attorney in Manhattan filed a civil forfeiture complaint to have the skull returned to Mongolia and Cage returned the skull and was not accused of any crime. Theft of artifacts and art from other countries is a problem around the world but particularly in the United States, where the number of officers assigned to art theft is so small. The FBI employs approximately fifteen assigned agents to art theft in the United States while Italy employs hundreds. That number is representative of the importance placed on art theft in America. When the cultural norm does not recognize the importance or support the arts of a nation, there is no determination by government to demand stronger policing at any level.

6

LOOTING OF ART AND ARCHAEOLOGICAL SITES

Let's assume you spent hundreds, thousands, or millions of dollars on art or an artifact that you purchased, with documentation of provenance—or what you believed to be its entire history—only to be told at a later date that it was in fact stolen. How would you react? Where would your sentiments lie? There are heated discussions at the international level on who owns art and artifacts and when they should be returned to their rightful owners. There is a division of opinions that vary between countries arguing for the return of stolen items to museums that claim they protect world culture through their collections. Other individuals argue, using policy, law, and nationalism as strategies to serve their own self-interests. In most instances the circumstances raise political, moral, and ethical issues that require specific investigation. As an individual it would be infuriating to lose a prized object, not to mention the money invested; however, provenance must be identified and buyers must purchase from reputable dealers as well as follow up to make sure the provenance is accurate. How, one might ask, does a museum not realize the provenance of an item might be questionable? There is an expectation that museums have the capacity to check on their purchases and when museums are found to be holding illegal items, one does wonder if they turned a blind eye. Some ask why does it have to be returned? When is it ethical to return an object and when should art be kept for the preservation of the object itself?

The United Nations Educational Scientific and Cultural Organization (UNESCO) works to safeguard cultural property around the world driven by the belief that all cultures must maintain their heritage through their art and artifacts for sustainability and by way of cultural heritage sites. As mentioned in previous chapters, history has provided us with numerous examples of victors returning home with the spoils of war as a means of annihilating their enemies and increasing their own wealth and military strength. UNESCO has recently added strategies to this cultural component of maintaining heritages worldwide. The process requires open conversations across borders for nations to agree on fair and all-embracing global solutions.

This is certainly a lofty goal and we wish UNESCO success in their challenging plan; however, human nature manifests itself at the individual level and across the board to governments around the world. These facets of human nature include greed—wanting as many items as they can amass for themselves. Another characteristic of human nature is ego; those with large egos believe art is rightfully theirs. Ardent feelings and a strong desire to own artwork, only for themselves, have captivated many art collectors and thieves. Another distinguishing emotion is resentment of an individual or collective who wants an item purely out of covetousness. Overindulgence is another trait shown by those who expect and demand to have what they want. Indignation or outrage may appear when a work of art is not returned to those they consider the rightful owners, regardless of UNESCO's intervention. Finally, we have idleness—exhibited by people who were not interested in collecting or paying for an item until they realized its value and now they have considerable interest. There are plenty of examples of fraud and theft that fall within these human characteristics. The transgressions described relevant to human nature and the similarity to the seven deadly sins is, of course, strictly coincidental.

UNESCO advocates at the international level, calling upon all countries to set clear policies and legal structures within their governments to secure cultures and safeguard their heritage. Despite the negative description of human nature offered above, UNESCO speaks internationally to a more refined set of values based on human respect and open discussion to protect the world's cultural heritages. Unfortunately, not all citizens or leaders within countries place a high value on their art and historical artifacts. A recent pressing issue involves militant attacks

against museums simply because they are "soft targets" that are open to the public. They also offer very little security to defend against a serious weapons discharge or against individuals whose intention is to damage or steal items within. Museums do not have the same protection following 9/11 that you will find in political/military, transportation, and transit sites—or at historical monuments within the United States. In the same way, archaeological sites are an easy target for looters to steal and sell in the arts and antiquities market. Looters take from open archaeological sites to sell in lucrative markets.

When museums and archaeological sites are targeted, the damage to tourism and museum attendance can be very costly. Although tourism is lucrative, and the most renowned museums are those with coveted items attracting visitors from around the world, damage to artwork and antiquities is the primary loss. As we continue to emphasize, there is also the inability to connect historical facts based on the location of items found at the site of an archaeological dig. Archaeologists must have a connection or clues to determine the location where items are found to build context. What is the time frame? What was the item used for? Who used the items and why were they left behind? History will look back at Afghanistan, Egypt, Iraq, Iran, and Syria as some of the most devastating destruction in the twenty-first century by groups of ignorant, artless, and uncultured violent men. There are major crimes of looting and thefts from countries at war as well as countries whose citizens live in abject poverty, but to examine the destruction in the Middle East will leave anyone with any respect for history physically ill.

Wars in the Middle East and groups such as ISIL (headed by Abu Bakr al-Baghdadi) that are representative of evil, have damaged heritage sites. ISIL destroys sites they consider offensive and idolatrous, based on their literal reading of the Koran. The militants practice ethnic cleansing, make slaves of their captives, starve their enemies, and behead and gas innocent victims. Sadly, as noted by art historian and author Noah Charney, it is terrorism in the Middle East that is drawing public awareness of stolen artifacts and the theft of history.[1] This is a double-edged sword when one considers that it takes the destruction and piecemeal theft of so many irreplaceable artifacts for the world to pay attention to the crime of looting.

One of the protected world heritage sites is the ancient city of Bosra in Syria, located near the border of Lebanon. Bosra is a significant

archaeological site with ruins chronicling the history of Nabataean, Roman, Byzantine, and Muslim civilizations and considered by UNESCO to be an open museum. After surviving 2,500 years the city succumbed to damage from military attacks. The damage is confirmed by some pictures from the local area in conjunction with the following: University of Pennsylvania Museum of Archaeology and Anthropology's Penn Cultural Heritage and the Smithsonian Institute in cooperation with the Syrian Heritage Task Force; and Geospatial Technologies and Human Rights Project of the American Association for the Advancement of Science. The organizations pooled their expertise utilizing satellite images. Although the damage is noted on the satellite images, it cannot be determined how extensive the damage is to the heritage site. What can be seen is damage to the second century AD Roman Theatre, once hailed as the oldest and best preserved in the world. The theatre is still intact but there is a ramp of earth over the eastern staircase with a berm around the entrance. There are mortar holes from shelling to some of the modern buildings and one hole noted in the Al-Omari Mosque (AD 720).[2]

There are confirmed reports in March of 2015 by the BBC that Nimrud has been bulldozed to the ground. Nimrud, once the second capital of Assyria, is located in Northern Iraq. The jihadists blasted, used power tools, and chipped away at some of the most important statues and carvings in the world. Gone forever are beautiful carvings of lamassu, an Assyrian deity, portrayed with the head of a human and the body of a lion or ox, and sometimes depicted with wings. The militants continued their carnage at Mosul, north of Nimrud, destroying 100,000 books, maps, and manuscripts containing religious texts and theses at the Mosul Library. These acts, which destroyed documents that are thousands of years old and belong to the history of the world, is considered by UNESCO to be a war crime. Appealing to a higher enlightenment is lost on the militants who claim Sharia laws determine that college and higher education is un-Islamic. For propaganda purposes, militants recorded and uploaded videos of the destruction of priceless artifacts at Mosul's central museum. The video shows the world the fanaticism of these barbarians who profess religious zeal for the prophet Mohammad by destroying any and all forms of antiquity as deity. With the claim of destroying idolatry, ISIL is seen breaking the beautiful stone depictions of the three-thousand-year-old Assyrian winged bull

and the two-thousand-year-old statue of the king of Hatra.[3] While those damaging these beautiful artifacts portray themselves as righteous Muslims, overshadowing this façade, the same ISIL members are looting and selling artifacts and art treasures to finance their jihad. During that period, it was estimated ISIL brought in approximately 1.5 million per day with a net worth of $2 billion. Money is collected through 20 percent taxes, 40 percent control of wheat production, $46 million in kidnapping and selling crude oil on the black market (obtained by highjacking oil trucks), taking and demanding funding from locals, and looting artifacts to sell on the black market.[4] ISIL sends citizens to dig through the rubble of their destruction as well as to other known archaeological sites. With the use of unskilled people, damage to the sites and the artifacts occurs because the digs are not being unearthed with the care that would be accomplished by trained archaeologists. Although the public is more aware of looting and using artifacts to fund terrorism due to the media coverage of ISIL, what is not understood is the amount of looting and theft that occurs around the rest of the country.[5] Dr. Amr Al-Azm, of the Middle East History and Anthropology department of Shawnee University, claims the cultural heritage under the control of UNESCO is only designed to deal with state institutions. The regime only controls 30 percent of the country; therefore 70 percent is basically left unsupported by the international community and organizations such as UNESCO. The only ones left are the activists, the people who put their lives at risk to go there. The real problem is getting resources to those outside the regime control, the unsupported actors protecting the cultural heritage.[6]

U.S. Customs and Border Protection (CBP) noted an increase in imports of Iraqi and Syrian property, raising suspicion that antiquities and looted art are being smuggled into the United States. In concurrence the Federal Bureau of Investigation (FBI) issued a warning to dealers and collectors regarding ISIL trafficking in antiquities on the black market. The FBI is warning that Americans are being offered antiquities from Syria and Iraq, and ISIL is profiting from these sales to fund their terrorism in the Middle East and around the world. By purchasing questionable items without provenance or an export license, buyers could be prosecuted for financing a terrorist organization. While the government is not prohibiting the purchase of items from the Middle East, they do however claim that while there are legitimate pur-

chases to be made, buyers must be diligent and do their research before buying from Iraq, Iran, Syria, or other countries whose treasures are being looted (FBI, ISIL and Antiquities Trafficking). The FBI recommends the purchaser review the Red Lists such as the Emergency Red List of Iraqi Antiquities at Risk, published by the International Council of Museums.[7] The Red List offers a description of the missing items as well as color illustrations. Items of antiquity are the most popular types of artifacts and are banned from being exported or imported. The Red List also cautions buyers, recommending they look for suspicious markings, such as any reference numbers in ink or "IM" for Iraq Museum, stamped or written anywhere on the item. Another marking is cuneiform, a form of picture writing that is vertical, horizontal oblique lines with triangular ends. Cuneiform is often found on clay or stone objects. Finally, any item with Aramaic or alphabetic Arabic writing that is usually in ink. Unfortunately, undocumented looted art, extracted from Europe and the Middle East, is extremely difficult to identify. Collectors want the items for their collections, so they are buying these items legitimately believing they are legal or simply turning a blind eye. The items are then placed in their personal collections making it more difficult to make a connection to stolen or looted property.

It is the Western market that is the driving force for the sale of illegal art and antiquities and this appetite for cultural icons continues to fuel the black market. The United States and Britain are the largest art market in the world followed by France, China, and Belgium. This illegal black market is offering bargain prices for some of the world's great treasures. Buying antiquities at a great price could mean that they are most likely an imitation or they are illegal. The same people who love the arts and history of antiquities delude themselves into believing they are saving these items from destruction or helping poor citizens who found the items to feed their family with the money earned from selling the artifact. Bargain prices paid by Westerners usually denote looted or smuggled goods. The truth is, the market for illicit artifacts is directly linked to the Islamic State and is fueling the terrorist movements in the Middle East and around the world (FBI, ISIL and Antiquities Trafficking, August 2015). Bargain prices for antiquities may be seen as a great investment but antique dealers must consider the provenance and export license for these objects. Buyers cannot simply contact an archaeologist to have an item appraised after a trip abroad or

after having purchased an item off the Internet. Archaeologists avoid appraising antiquities because of legal and ethical principles; and, more importantly, the sole purpose of their discipline, which is the scientific study of fossils, relics, and remains of past cultures.[8] There is an argument that items with provenance are appreciating in value more than those without provenance.[9] This argument is undermined with the excess of looted items sold on the black market by ISIL. The antiquities are generally not recognizable and do not appear in the Red List or other documented lists of stolen art, so they are bought and sold in the open market.[10] The question becomes one of ethics when buyers are purchasing antiquities during this time in history when we are aware of the prolific damage and looting of ancient sites by ISIL. It is a stretch to believe that collectors would not be suspicious of artifacts coming onto the market without provenance or proper export documentation. How do stolen and looted art and artifacts end up in museums and private collections with national and global laws in place?

Back to the question at the beginning of the chapter: what would you do if you purchased an item that was costly and sold to you with documents of provenance only to learn it was removed from an archaeological site and sold illegally? Would you be ethically bound to return the piece belonging to the country of origin, or would you argue that there were mitigating factors that must be examined including the date, when the item was removed from the country, or whether it was subject to permanent loss or damage because of the political situation in the said country? Museums have similar ethical guidelines that they are strongly encouraged to follow to avoid costly or illegal errors when purchasing or receiving donated items. The UK Museums Association Ethics Committee has a set of guidelines that are basic principles to be followed by all museums. The rules include rejecting any item that appears to be newly damaged from its social or historical context "unless there is an exceptionally strong reason for acquiring it"[11] and all items stolen or illegally removed from an excavation site, wreck, or monument unless an agreement is made with the country of origin. Museums are to confirm legal title, perform due diligence checks, and record attempts to ascertain provenance. When items do not have provenance, it is acceptable to have the previous owner write out the item's history, sworn in an affidavit. Again, the ethical code recommends museums refuse to purchase items that are believed to be recently dam-

aged from a historical site unless there is "an exceptionally strong reason for acquiring it."[12] Human remains may not have legal title; however, the museum must document terms of rights and responsibilities rather than ownership. Museums are not to acquire items that are better owned by another museum for care, access, or content or items that are better held by individuals, groups, societies, or people. The guiding principles for museums do address the moral dilemma of receiving an illegal item that would otherwise end up purchased by a private collector, never to be seen again or disappeared into the art trade. When this occurs, the museums are directed to refuse the item except for two situations: if the item is taken from an unstable country or from one at war. If this is the case, the item may be temporarily housed or held in trust for that country providing the museum has the approval of UNESCO. The second exception is when an item surfaces that originates from the local area but does not have provenance. The museum may act as a holding place until the rightful owner appears; however, they are warned not to pay too much for the items because it will only promote further illegal behavior. Finally, museums must realize that, regardless of their choices, criminal or civil proceedings could be initiated against them. Dr. Amr Al-Azm, believes no matter how far abroad items may be removed from Syria, they should ultimately be returned once the war is over or the area is settled. He believes the items should be taken and kept in safekeeping with the agreement that they will returned to the country of origin. The problem with this concept is that it is never a black-and-white issue when there has to be agreement over when the item will be returned to the country of origin. Who decides when the conflict is over or when the regime is stable? Dr. Amr Al-Azm had pointed to the Iran/Iraq conflict and had asked, would we want to return items to Saddam Hussein or for that matter when is the conflict considered over when we look at U.S. relations with Cuba? The challenges are not easy and there would also be the question of holding the items in special conditions to maintain their integrity and composition. By going to this expense, does this mean those holding the items should be allowed to display them and profit in this way? It is not an easy question, but it is an ethical question that needs to be addressed by the international community.

The media is full of examples of museums or collectors exposed for having illicit art and artifacts, drawing attention to the problem. The

incidents publicized are not always as clear cut as the media presents. As with the ethical principles of museums there are usually other underlying circumstances. In 1983 the Minneapolis Institute of Art (MIA) purchased an Athenian red-figure volute-krater from a well-known dealer who claimed it was from a private Swiss collection. In fact, the krater, a vessel for mixing wine, was illegally excavated in Italy and linked to a criminal investigation into another dealer, Giacomo Medici. The antiquity was returned to the Italian government after the staff at the MIA researched its history and the board of directors decided to return the object. It was not a speedy return because there was a change in directorship during the investigation by the MIA, but it was returned. In 2006 the Museum of Fine Arts (MFA), Boston, completed negotiations with the Italian government to return a number of objects looted from Italy. Some of the pieces were sold by Robert Hecht, an American dealer who is on trial in Rome. Marion True, the former curator of the J. Paul Getty Museum, is also held on charges in Italy for dealing in illicit excavated works of art. One of the pieces returned was donated in 1991 to the MFA by Shelby White, a trustee of the museum whose private collection is still being investigated by the Italian Carabinieri. Other pieces were obtained through Swiss intermediaries and galleries. The MFA contends that while the Italians have provided strong evidence of their provenance, they maintain the items were acquired in good faith.

The MFA was not as generous when Guatemala requested the return of 138 pieces of Mayan art, claiming the Guatemalan government could not prove ownership. The items were purchased in 1987 and donated to the museum in 1988 from William E. Teel, a private collector. The MFA director, Mr. Rogers, claims the disputed pieces are on loan and the museum does not have legal title, so they are being displayed as opposed to set aside in a private collection. The Guatemalan government asserts the items were stolen from Mayan sites in the jungle and smuggled into the United States without export permits. Guatemala has required export permits since 1947, while the United Nations accord was signed in 1970. The United States did not sign the United Nations accord until 1983, so the items did enter the country legally according to American law, but it is still contrary to international law.

In 1987, when the Mayan items were purchased, a lawyer was consulted who assured the museum that they had clear legal title. There is

still an ethical gray area when considering the items were taken out of the country without export permits and therefore removed illegally from Guatemala. If the items can be proven to be taken from another country illegally, is that not clear evidence of provenance and ownership? According to the Museum Association's ethical guidelines,[13] museums have an obligation to determine ownership particularly if the item is stolen or taken from an excavation site. The difference between the UK guiding principles and those of the American Alliance of Museums (AAM) is that museums in the United States draw up their own ethical guidelines in affiliation with the AAM. Each museum has its own standards and guidelines based on the broad principles outlined with the AAM. The Museum of Fine Arts, Boston, considers this a legal matter and the problems with looting should be settled within their own country of Guatemala. There has been public condemnation of the MFA by directors of other American museums, so this sentiment is obviously not held by all museums in the United States.

Turkey is taking a different approach in retrieving artifacts removed from their county. They are demanding what they claim is rightfully theirs from the Metropolitan Museum of Art in New York (MET) as well as from the British Museum in London, Berlin's Pergamon Museum, and the Louvre in Paris. All museums have refused to return the demanded items. Berlin returned a 3,300-year-old Hittite sphinx as a goodwill gesture even though it was legally taken prior to the UN accord.[14] The Turkish policy is a form of blackmail, demanding the return of items that were, in some cases, taken over a hundred years ago. If the items are not returned from foreign soil, Turkey refuses to renew permits to dig at archaeological sites. When countries such as France, England, and Germany refuse to return what Turkey demands, Turkey bans the archaeologists from these counties from working at any of the sites. The archaeologists see this as a devastating blow to science and culture.[15] It is somewhat contradictory for a country to demand their artifacts returned when they have no legal international claim and at the same time destroy their cultural history for the sake of updating their infrastructure. Turkey is one of a number of countries using blackmail and strong political posturing to have artifacts returned. India and China are also making demands for the return of art and treasures from Western museums and collectors; whether they will be returned to a museum or placed in someone's private collection is not assured.

There has been much criticism of Western collectors and museums for their public refusal to accept illicit artifacts while still displaying works of art with dubious provenance. While museums have more public checks and balances, private collectors, because of the lack of public transparency, are able to circumvent the legal inquiries of their collections. Purchasing illegal items has only increased the supply and demand by Western dealers and museums resulting in an underground business comparable to the drugs and weapons trades. The business of art is a complex billion-dollar industry. Unlike the philosophy of UNESCO—to preserve world culture—there is a decided lack of ethics in the underground business of arts and antiquities.

7

ECONOMIC IMPACT OF ART AND ART-RELATED CRIMES

For many Americans, art may be less pressing than sports, work, and politics, or they believe it does not impact their daily lives. When art and artifacts are stolen, aside from the great loss of historic or aesthetic value, the public pays dearly in concrete financial terms. Members of the general public that believe art has no relevance in their lives must at least consider the negative monetary toll art theft and fraud cases take on our society. It is difficult to put a price on the cost to society of all stolen art and artifacts, but it is possible to point out when the expense is retrieved from the public purse. Museums and public collections that failed to prove provenance before purchasing items have lost millions of dollars that might otherwise have been used to purchase legitimate items. Law enforcement interaction—whether it results in confiscated smuggled items at border checkpoints, undercover investigations, and major seizures from long-term investigations—cost tax payers millions of dollars. Countries lose taxes when art is stolen and traded as currency by criminal groups who use the items to launder money. The loss of revenue to the host countries where items are removed cannot be discounted. Archaeological digs overseen by government agencies who charge for permits to work the sites lose financially. Losses in employment and tourism, and the use of stolen items as currency all undermine that country's financial resources. The United Nations claims it is the third highest-grossing criminal act. The theft and trafficking of cul-

tural items may not be the oldest profession, but it certainly rivals for first place in the standing.

Since 2007 Homeland Security Investigations (HSI) and Immigration and Customs Enforcement (ICE) have trained at the Smithsonian Institution's Museum Conservation Institute to educate special agents on techniques to handle and store cultural property.[1] The special investigators work with national, state, and local agencies as well as Interpol and governments overseas. Following 9/11, federal investigators realized the ease of transmitting cash from one country to another contributed to the funding of the terrorist attacks on the Twin Towers of the World Trade Center in New York, the plane crash in Pennsylvania, and the plane used by terrorists to crash into the Pentagon. The government took steps to halt terrorism by first stopping the funding for their operations. Since the Patriot Act of 2001, it is very difficult to send money to the United States without scrutiny. Banks and financial institutions must comply with the laws used to identify when large sums of money are transferred across borders.[2] Since 2004 the trade-based money laundering (TBML) initiative was put in place to identify criminal financial activity through a number of ways. TBML looks at a variety of activities including falsified trade documents to move illegal goods and financial transactions of a criminal nature.[3] Immigration and Customs Enforcement estimates that criminal and terrorist organizations utilize various schemes and legitimate trading to launder billions of dollars each year. Art theft, fraud, and sales are crimes that fit into the types of schemes carried out by criminal and terrorist groups. The Trade Transparency Unit is interesting; it began in Washington DC in 2004 and partnered with a number of countries with trade transparency units who look for patterns and anomalies in trade by examining transactions from both countries. The countries involved use software in conjunction with investigation techniques to identify illegal transactions utilizing a computer system called the Data Analysis and Research for Trade Transparency System. With data that is gathered from various countries producing more open trade transactions, this system helps identify customs fraud, smuggling, and tax evasion. The initiative is meant to diminish money laundering and transnational crime and terrorism.

A long-running and expensive Homeland Security and ICE investigation known as "Operation Hidden Idols" that covered several nations and a host of museums and private collectors around the world ended

in an arrest. Subhash Kapoor, who owned a well-known art gallery in Manhattan in New York City, had been running a $100-million illegal smuggling operation of antiquities. Kapoor was arrested in 2011 and extradited to India to face criminal charges. Many museums purchased from Kapoor because of his positive reputation and lengthy business dealings as an import–export dealer of antiques from India and Asia. The financial loss to museums by Subhash Kapoor are numerous. The David Owsley Museum of Art at Ball State University in Indiana, for example, held a bronze religious sculpture of Shiva and Parvati looted from South India; they had to surrender it to ICE so it could be returned to the Indian government. The Honolulu Museum and the Peabody Essex also handed back items that they had purchased from Kapoor.[4] The pressure to return the costly items to their rightful owners, and the negative press associated with those who purchased from Kapoor, is a strong signal from the authorities that museums and collectors must follow due diligence when purchasing antiquities. Lark Mason, a renowned expert in Chinese art and antiquities, often seen on television on the Antiques Roadshow, complained of the heavy-handed approach toward gallery owners. Mason claims dealers are open to work with law enforcement when they have questions about objects. He would rather be approached openly than treated as a criminal because the items are all publicized and dealers are open about their offerings—no shifty approach is taken, as the law suggests.[5] It would be ridiculous for criminal investigators to jeopardize their investigations by warning those who are under scrutiny. Complex investigations, such as Operation Hidden Idol, are costly, lengthy, and connect known associates nationally and internationally who are involved in the same type of criminal behavior.

Museums and gallery owners have tuned a blind eye to questionable provenance when it comes to in-demand antiquities. It is their livelihood and they stand to make significant profits by letting items slip by with the minimum of due diligence. Dr. Amr Al-Azm, professor of Middle East History and Anthropology at the Shawnee State University of Ohio refers to the "coin collectors or guardians of the treasures as the National Rifle Association (NRA) of the art world." Buyers and sellers resell with shaky provenance, particularly at the large auction houses, which are willing to turn a blind eye when there is a buyer. Dr. Amr Al-Azm says it is shocking how little you have to do to prove provenance, and the art market has, in many ways, encouraged this because they are

able to let things slip through the system. Every once in a while some-one gets caught, throws their arms up in the air, apologizes, and contin-ues with the same practices. As the NRA uses considerable financial resources to enhance their markets in the United States and across the globe, so too have the dealers who sell antiquities smoothed their way into museums and private collections using the same shifty approaches.

There are public examples of this contentious relationships between art dealers and offshore banking. Art is used as fraud for tax evasion and money laundering purposes, and these criminal activities were brought to light with the publishing of the Panama Papers in 2016. The publica-tion of information held by the Panamanian law firm Mossack Fonseca links the ultra-rich to offshore companies established by the law firm. Although it is not illegal to own an offshore account, an account or shell corporation is used to hide money and valuables such as art. One such revelation is the relationship between Sotheby's and an owner of a painting stolen in France from Oscar Stettiner, a Jewish art dealer dur-ing the Nazi occupation. The lost Modigliani painting *Seated Man with a Cane* (1918) was sold by Christie's auction house in London in 1996 to a Panamanian company, International Art Center (IAC). The prove-nance at this time was offered as Roger Dutilleul, a French collector. In 2008 Sotheby's offered the painting as possibly belonging to Dutilleul or Stettiner. The claim of rightful ownership is by Philippe Maestracci, the grandson of Stettiner. The recent revelation via the Panama Papers exposed the Nahmad family as the owners of IAC. The Nahmad family has claimed, over the years, that they did not own the painting, saying it belongs to a company called IAC. Sotheby's was subpoenaed producing two letters acknowledging they knew the whereabouts and owner of *Seated Man with a Cane* as well as the Stettiner claim but refused to disclose Nahmad's identity, as is the general policy of Sotheby's. As the lawsuit moves forward by the Stettiner estate against Helly Nahmad and his gallery, it remains to be seen what the court will ultimately decide. The argument is that IAC owns the painting and not Helly Nahmad, who was fifteen years old when the painting was purchased, and the gallery in his name did not exist at that time. A further question is whether the Stettiner claim can prove ownership of the painting during the Nazi occupation.[6]

From 2007 to April 2016, HSI has repatriated more than eight thou-sand items to more than thirty countries while working with foreign

police as well as law enforcement within the United States. Investigations for illegal trafficking of art, cultural property, and antiquities that cross county, state, and international borders in an attempt to fracture international smuggling comes at a heavy cost to taxpayers.[7] In April of 2016, in an elaborate formal ceremony in New York, ICE and HSI returned dinosaur skeletons and other fossils to the Mongolian government. The fossils recovered by HSI were no small matter. They included pieces of nearly complete skeletons of bactrosaurus, protoceratops, and psittacosaurus, a nest of protoceratops eggs, and the skulls of an alioramus and a psittacosaurus. Mongolia holds the largest-known paleontological concentration of dinosaur remains compared to anywhere in the world. Mongolian law prohibits the export and private ownership of dinosaur fossils; however, this has not stopped looting and smuggling of the fossils.

There are dealers who claim some countries are not as diligent in the supervision of their arts and antiquities compared to countries such as Italy and Greece, and because of this lack of monitoring, it should be the government who is responsible for looted items rather than the dealers who purchase them. This, however, is not the state of affairs worldwide or the direction in which countries are moving to protect antiquities. The international move is away from art and antiquity sales completed in secrecy, and Western countries will be accountable for their purchases. The recent creation of the International Anti-Corruption Coordination Centre to crack down on global corruption and recover looted assets is a testament to the direction of this cause. The London-based center will work with Interpol and law enforcement agencies around the world. The United States, Canada, Australia, New Zealand, and Switzerland are also working in a coordinated effort to investigate and recover stolen assets. In May 2016 the leaders of approximately sixteen countries met for the first time to expose corruption worldwide so there is no place to hide. Corrupt nations and organizations also attended, including Nigerian president Muhammadu Buhari and Afghan president Ashraf Ghani. The heads of the World Bank, International Monetary Fund, and senior members of the International Olympic Committee were also in attendance. Panama was not welcomed because they only wanted those at the table who are addressing corruption within their organization or country. The summit focus is to expose corruption, to leave no place for the corrupt to hide, and to

punish those who are corrupt while supporting those affected by corruption. Overall the fight is to remove the culture of corruption by addressing the issues with a global response that would include international anti-corruption laws and stronger international institutions. Other issues to be addressed at the conference include corporate secrecy and government transparency.[8]

The International Monetary Fund (IMF) publishes the consequences of money laundering and its link to terrorism and crime, and how that affects the broader financial economy. The IMF claims the criminal activities and costs of money laundering include undermining the honesty and stability of the financial sector and economy. This includes financial institutions and the distortion of capital internationally as well as the decline of foreign investment. The direct consequence on a country's economic performance is limiting resources for other positive investment or infrastructure, health and education, with the possibility of harming interconnected economies of other countries. Money launderers and those financing terrorists look to countries with weak laws and few controls, where money can be transferred without scrutiny. The IMF estimates the annual cost of bribery at approximately $1.5 to $2 trillion yearly, or roughly 2 percent of the global GDP.[9] This cost may appear exorbitant, but then you have to consider that bribery only takes into account one form of corruption and there are so many more.

8

MUSEUMS

Our Identity and Culture

When discussing art and cultural crimes, it is important to mention museums, because they play such a vital role in the protection, display, and preservation of artwork, as well as offering educational benefits and an economic benefit to the country and culture that surrounds and prizes the institution. These institutions play such a significant role to the community but are so often overlooked by the general public in their day-to-day lives. While museums are major tourist attractions, this makes them an easy target for terrorists who disagree with a country's foreign affairs and use attacks to hurt that country's economy by crippling their tourism trade. Those who reside within that community may not appreciate, or choose to ignore, the vital role these museums play in their cultural identity, with their heritage displayed within the museum walls. The museum defines and is driven simultaneously by the cultural identity of the community it resides in, as well as the communities and cultures it displays and represents.

Culture is not simply the history of a community, it extends into many different areas simultaneously representing and defining the community. The artwork, the historic artifacts, and the stories and myths that shed light on the livelihoods and values of those who lived in the distant past give context to our own daily struggles. While our own, more practical histories define our national or regional perspectives, we use the knowledge of foreign ideologies to further influence and define

ourselves. Society uses ancient models of democracy to set the basis of our own political ideals, and we use the horrors of past wars to prevent similar situations of widespread death and carnage in our modern land-scapes.

The importance of museums in reference to our culture cannot be overstated. The experts who work within are dedicated and trained to safeguard and preserve some of the world's oldest relics and artifacts. In the case of older items, which are so ancient they risk disintegration if left out in the atmosphere, the displays themselves must be specifically pressurized and climate controlled at all times. Each display of ancient artifacts needs to be carefully monitored, and while security is not al-ways of the utmost concern, the preservation of the work is always a first priority. These works are priceless artifacts, and the preservation of that history is of utmost importance to museums.

The responsibility of preserving the items housed within museums extends further than simply monitoring the climate and preventing deg-radation of the artifacts. Eventually the items, both ancient and mod-ern, will degrade or suffer damage. Regardless of the measures taken to protect an item, human error is a constant factor that inevitably results in accidents, mishaps, and unavoidable damage. While the staff takes a number of steps to avoid causing undue harm, staff members are also trained to repair or replace parts of the displays that may be damaged. It takes dedication and patience to accomplish this skillset. To maintain the historical accuracy of the works, the conservation experts must use materials and pigments that would have been traditionally used in the original artwork. When repairing paintings, these experts mix custom paints to match the original coloration as closely as possible. When repairing a sculpture, the process often includes using glues or solvents that were used during that same time period, and tedious amounts of time spent on making sure the additions blend seamlessly with the original material.

In the past, irrevocable harm has been caused when artists altered famous works of art for one reason or another. Depending on the time period and social mores, artists would "censor" a work of art, covering genitalia with leaves, or make realistic depictions of gods and religious figures as perfect icons. This included neglecting to add moles, scars, or negative physical features to portray the individual as more attractive than they were in real life. As the major political and religious views

changed, the artistic representations that coincided with the subject matter changed as well. Many nude sculptures were damaged in order to replace the genitalia with fig leaves, and numerous paintings were painted over to make them "acceptable" in the current political leader's eyes. These alterations and modifications were not considered wrong or unethical; rather they were accepted as a repair or conservation step. While today it is viewed as destruction or vandalism, it was historically viewed as perfectly acceptable to alter a work in order to appease those in power. The Sistine Chapel ceiling is considered one of the most iconic and impressive works by Michelangelo. However, the fresco titled *The Last Judgement* was not always viewed as a masterpiece. In fact, the depiction of nude human spirits was considered vulgar and supposedly made it difficult for the viewer to focus on the religious aspects. Michelangelo's apprentice would later paint loincloths over the depicted figures. Another example of art censorship is somewhat more recent than Michelangelo's fresco. The statue *Bacchante and Infant Faun*, created by Frederick MacMonnies in 1894, depicts a Roman wine deity, Bacchante, dancing with her infant child. While the nude statue was not considered inappropriate, it was perceived to have a more sinister nature. The work was going to be moved to be displayed in the courtyard of the Boston Public Library; however, the Women's Christian Temperance Union expressed their outrage at the "drunken indecency" that was being demonstrated. The statue was instead moved to the Metropolitan Institute of Art (Met), where it has been since displayed in its drunken and nude state.

The preservation and care of artwork and artifacts is a primary function of a museum's duties, but it is also important to keep in mind that in order to function and benefit society, the museum needs to be accessible to the public. Hayes Scriven, executive director of the Northfield Historical Society (Northfield, Minnesota) says, "The museums give a cultural identity, and a background that goes into our national and cultural identities, the community needs to witness these artifacts and works being displayed in order to fully understand their impact on our society, and on ourselves as individuals within the larger context."[1]

Another issue many museums face, which is not commonly considered, is the that of pricing artifacts. In police reports, and news articles, including almost every description of the thefts and destructions in this book, a price value is listed on the work and artifacts. While it is impor-

tant to price art and historical collections in order to insure and safe-guard those investments, the idea of ownership of these items is a contentious issue. When items are donated to a museum, the owner relinquishes all ownership and the museum may do what it pleases with the donation. This includes lending it to another museum, selling the item, or placing it in storage in the basement. The question of who owns the article is a theoretical argument that disturbs many individuals. There are those who believe the great art and artifacts of history belong to everyone, and a value cannot be placed on something that cannot be owned. On one hand you have the general American Dream, and that dream tells us an individual who worked and earned their money has the right to purchase items and objects as their own. Owning lavish works of art created by masters of their craft is a display of wealth, opulence, and power—something that has stood true for all of time, from warlords, to kings and queens, conquering nations, and now suc-cessful business people and individuals from all backgrounds. What is the point of amassing wealth and power, if you can't display it and own famous works that would make others envious? Executive director Hayes Scriven from the Northfield Historical Society was kind enough to talk with us on the topic of fiscal values being placed on the items displayed in museums. He stated, "I feel that the artifacts in museums shouldn't be priced and evaluated for the public record, or for the IRS. As a business plan it is important to insure the items; however, each item doesn't belong to the museum itself. You can't own a history or cultural artifact; all of the artifacts belong to the public, and as such it's unethical to think of those items as your own."[2]

Many in the area of cultural preservation agree with his statement. The overall idea is that if a community allows work to be destroyed, stolen, neglected, or offered up for fiscal incentive, the items never truly belonged to them in the first place. In order for these museums to be treated with respect, the works of art and cultural artifacts have to be taken care of, and the museum must show the same respect to the community through support and reverence for that cultural display. Ultimately it comes back to the community's ability to see and under-stand the importance of the art, historical artifacts, and documents, and how they affect our community and individual identities.

In another perspective, placing a financial value on artwork and artifacts appeals to the general public. This can cause a number of

concerns, as well as benefits. It certainly helps raise awareness of the value of items displayed within museums. This awareness, however, may also draw attention from thieves, forgers, and vandals for obvious reasons. The price tag places value for insurance purposes, and it is important that museums insure the works they possess. While the loss of art and artifacts is a permanent loss, and the items can never truly be replaced, with the reimbursement from the insurance company, the museum would be able to rebuild aspects of the display and continue with its goals. By having fiscal values on art and antiquities, it is also easier to appeal to the more conservative mindset that views life in dollars and cents. There is a sector of society that does not place importance in the intrinsic value of museums but can appreciate the monetary aspect. While those who seek to learn, create, and discover art and cultural artifacts have very little reason to doubt the necessity for the protection of this work, it is more difficult to convey that message to those who live with different world values and priorities in life.

It is especially significant to stress the importance of the protection of these artifacts by law enforcement personnel. While many police may be taught to understand the role of art and cultural icons in our lives as a whole, the sad reality is that this topic often does not compare to what they enforce on a daily basis. After all, what is the value of a painting compared to a child's life, the safety of a domestic partner, or the well-being of an individual on the street? With the added monetary value, law enforcement can see the importance in concrete terms and compare this value to the thefts and sales of firearms and drugs. It becomes even more important for the security personnel who work within the museum, helping them better understand what they are in charge of safeguarding.

Security is an aspect of museums that often gets overlooked. It is a tricky business having to maintain the open and inviting atmosphere, while also ensuring all entrances, exits, and any other possible security risk is assured. Banks and new government buildings consider security in the architectural designs but the majority of the major museums were constructed when security was less of an issue than it is today. This shows in a number of aspects of museums, from welcoming the public to access the building with long stairways or large ornate doors and open layouts to tiny rooms where visual scrutiny is limited. Security

personnel hired to surveil the internal and external areas of the building are generally an afterthought.

Museums desire an inviting and welcoming atmosphere; after all, if there was little attention paid to the external aesthetics, what would one expect to find within but more of the same? Many museums find the balance between the welcoming external and internal architecture, while maintaining a secure environment; however, this can cause a wide range of problems. In order to advertise, museums will display photos of the galleries, announce famous or iconic items being displayed, and attempt to raise awareness on the subject in order to generate attention and attendance. With this type of publicity, the museum instantly becomes a target for those who would have an interest in those items. It also gives these individuals instant access to most of the information that they would gain from visiting the exhibit. Without attending the museum, outsiders can see where the items are displayed, how they are displayed, and where in the building this exhibit stands. From that, thieves can readily gain information on the external aspects of the building—from walking around it, visiting the museum, or simply looking up images on the internet and using mapping software to get access to the rooftop information.

The security hired by museums is frequently a major area of concern. Often museums hire private security agencies, taking in security guards who come from a wide array of backgrounds and specialties. In these cases, the security guards may have experience from being personal bodyguards, event security, or any other security related position. While this experience can bring valuable insight, and an opportunity to view an issue from multiple angles, it is also difficult for these individuals to relate to the arts aspect of a museum, or be fully capable of understanding the climate and care that the items require. In many cases, the same negative notions of art and cultural artifacts so prevalent in American law enforcement are shared by those in security fields. The organization of the command staff becomes an issue with an outside agency, with the problem being too many bosses and multiple policies. The security staff reports to multiple individuals, who have different policies to keep track of depending on the job site. The responsibilities become confusing when they are instructed to do something different in each position. This can become extremely confusing, and when faced with an emergency situation, can result in disorganization, or even lack

of action altogether. Museums with their own security on staff, led by a member of their own organization, also face a number of issues. Security staff is viewed as low on the list of preference in staffing. Financial support is prioritized for employees caring for and acquiring new items for the museum, as well as those who conduct research and are in charge of the displays. These curators spend years researching and acquiring academic titles as experts in their areas, to provide prestige and knowledge in their chosen discipline. Sadly, security staff often come from a limited educational background, and the financial support reflects this perspective when they are paid minimum wage. Even in the case of an institution such as the Isabella Stewart Gardner Museum, the security guards on the night of the infamous theft in 1990 were college students, getting paid minimum wages to work overnight.[3] One even reportedly stated his displeasure at working for an organization that was so willing to put its financial support toward the display but providing so little toward its staff. As is often the case, the lack of respect given by an employer can drastically alter the motivation of staff members.

Security features within museums vary greatly, as does the effectiveness and the cost to the institution itself. Many museums will often use minimal security measures; for instance, pressure sensors on the glass cases, and on the external windows, are fairly simple, cost efficient, and effective. These sensors will be set off if too much pressure is applied to the glass casing, and would certainly be set off if the glass was entirely broken. Once triggered, this would set off an alarm, informing the curator or the local law enforcement of the problem. There are always the laser beams we see in the movies, which always look effective. Unfortunately, the idea of using motion-sensing laser beams to protect artwork is a creation of the entertainment industry. The mere idea of limiting a sensor to a single beam going from point A to point B is, to put it simply, horribly inefficient. While it may seem cool, and makes for some tense and thrilling scenes in movies and television, it simply is not a good method of protecting anything. Museums that utilize motion sensors will, after a certain hour, use them to gauge any movement within the museum, or contain them to certain sections that will set off an alarm. Unfortunately, this will negate the possibility of night security conducting patrols of the areas being monitored, so in some cases museums have simply used the motion sensors to track all movements at

specific times. It allows security a printout of how long a person was in the room and where they were situated within the room.

There has also been a great deal of research into Global Positional System trackers (GPS). The use of these in terms of artwork would provide a way to mark each work of art stored within the museum. As such, it will send a signal updating the system to the whereabouts of the work, and if it were ever moved from the building without authorization, it would sound an alarm. If it were stolen, this system would allow it to be tracked. Unfortunately, it has been found to be cost prohibitive. With each continual update of the system to trace the whereabouts of the item, the cost rises and uses up more storage in order to track and update, therefore increasing the rate. Along with the aspect of cost, and constant rate hike, there is a set area where the sensors are effective, making it nearly impossible to locate unless they are kept nearby. This system hardly makes sense when the cost is so high and the range is so limited.

The use of video cameras is becoming fairly commonplace, not only in museum security but in all types of security. The access to a variety of camera types allows for the organization to place low-visibility cameras inside the building to preserve the overall interior aesthetics, while using more visible and durable cameras on the exterior of the building. These cameras will often feed to a single room or a program that can be accessed by anyone who is authorized. While it is also becoming more common to have camera systems actively recording, there are still a large number of organizations that have cameras that are not recording. This comes back to the question of price as well as the availability of data storage. While a camera will provide some visual deterrent, if the would-be criminal knew the cameras weren't actively recording, they would pay them little mind.

With the advancement of camera technology comes the additional problem of space required to house large quantities of video. To store video, the establishment needs a secure server area, where all the information is backed up; the secure server is often located on-site. This area needs to be monitored, and while an entire room can be used for digital storage, if the videos aren't set up to be deleted after a specified point in time, the organization will quickly find they have run out of space to store future videos. This is without a doubt an expense that can quickly grow. The installation costs in and of itself can become enormous, con-

sidering the wiring often stretches throughout the entire building in order to link all the cameras together on the same network. Even with this effort, if the criminal knows the location of the server, and there is no backup, the thief or vandal can make it a point to destroy the server or steal the storage device, rendering any recorded video obsolete and unobtainable to any investigation effort.

Many museums will opt to use a type of technology that is simple and allows for easy access as well as an effective way to lock down the building. By using programmable identification tags for the staff, the museum can install pads at each of the entrances. Using magnetic locks wired into the system, specific doors can always be locked, while others can lock at specified times. This allows the staff to be constantly iden-tified and have access to the building. At the same time, by checking the software and programming, a full record is available of who used what door and when. This could go a long way to identifying possible breaches in security or ensuring that the proper staff is on the location at the proper times. After all, in most museum thefts, a staff member is involved. The issue with this security method comes with the upkeep. Due to the constant use, areas such as doors become compromised and these violations are often ignored by the staff. By being overlooked, many doors stand the risk of locking improperly, or if the system is too lenient, the staff may take advantage of it without reporting. The system requires continuous vigilance and can be made worse with tricky and tentative programming issues related to locking mechanisms and com-mon glitches that require ceaseless attention to keep them functioning correctly.

Depending on the type of museum, whether it be a historical mu-seum, an art museum, or possibly a science museum, the security meth-ods will change considerably. Not only does the type of museum make a significant difference when considerations of security are taken into account, but the size of the surrounding community and the museum itself plays a vital role. The history of the building also needs to be taken into account. Some of these galleries and displays are built within cas-tles or mansions that are hundreds of years old. In the older buildings, tearing them apart to add additional security measures would signifi-cantly reduce the historical value and overall authenticity of the struc-ture. Adding an intrusive security system greatly reduces the reasons behind preserving the building in the first place.

Smaller museums and galleries inevitably find it more difficult to justify the added expense of advanced security systems. These institutions will commonly have several security measures in place, but without the financial backing and support from outside contributors, which many of the larger museums have, the small-scale museum will be forced to be extremely conservative with its expenses. As is the case, the acquisition of gallery displays, artifacts, or art is the reason a museum exists in the first place, and that is the reason for the focus of their primary expense. Almost all of the artwork that was stolen by Stephane Breitwieser, the thief who stole the works of art out of love, was largely stolen from small galleries or older buildings, where security was lax or nonexistent. His girlfriend at the time would distract the attention of whatever visitors or security were present, and he could simply take the art, put it under his clothes or jacket, and walk off without raising any alarms.

Larger-scale museums have much better security due to more flexible spending, but both small and large museums share a common problem that is prevalent in the majority of thefts; in most incidents of thefts from museums, it is an inside job. This could mean a curator, a volunteer, a janitor, or various other staff members who come and go on a daily basis. For this reason, investigators' primary suspects from the very beginning of the investigation are those on the inside. Those who work at the museum become familiar with the daily routines of all the staff. They hear about what security measures are in place, or what is being repaired or simply not monitored. These employees fade into the background because, after a while, the faces are all so familiar to everyone. Security can become lax or simply fail to surveil their fellow employees closely. This is, in fact, a common problem with law enforcement as well as security—the focus always being on those outside of our day-to-day lives, rather than looking at coworkers with a drive or motive. With all of these factors, and the added temptation for these individuals who are constantly surrounded by beautiful displays—as well as access to whatever artifacts and artwork are in storage—it is no wonder that those so inclined become seduced with opportunities: they cannot resist stealing.

While we have already mentioned the theft of the *Mona Lisa* as being an inside job, there are numerous examples of this type of inside theft. For a while the FBI looked closely at the staff at the Isabella

Stewart Gardner Museum, in order to rule out a possibility of it being an inside job—a theory that is still considered a possibility by scholars and investigators alike. A prime example of museum theft being an inside job took place in the State Art and Sculpture Museum in Ankara, Turkey. Between 2005 and 2009, a group of thieves stole up to 302 separate works amounting to a total value of $250 million. Of the items stolen, forty-six had been replaced with fakes and forgeries in an attempt to disguise the theft of the originals. According to reports, at least thirty of these items were of "dubious origins." The police were tipped off by an anonymous caller, who identified himself simply as "Daylight." Through this caller, the police quickly arrested and had in custody three individuals from the gang. The alleged leader, Ahmet Sari, is an antiquities dealer; Mete Aktuna and one of the museums security officers, Veli Topal, were the culprits. According to the source, the group replaced many of the paintings that were stolen by using forgers from Ukraine's Aivazovsky Painting Academy to paint fakes. The source also stated that the entire theft ring extends all the way up to the female deputy director of the Art and Sculpture Museum. If this is in fact true, it would go a long way to explaining the amount of artwork that had been stolen over such a long period without anyone notifying the authorities.[4]

In a more recent case, on March 16, 2016, it was announced that thirteen people had been arrested for their involvement in a theft that took place on November 19, 2015, at the Verona Civic Museum of Castelvecchio shortly after the museum closed. From the reports, three thieves entered the museum; one held the cashier at gunpoint while the other two took their time going through the museum, taking what they wanted. The night security guard said the thieves entered the building through a side door minutes before the alarms would have been activated. The thieves took over an hour removing the works they intended on stealing; then they took the night security guard's keys and escaped in his vehicle, which was parked outside. As of March 16, 2016, the Italian Carabinieri working alongside the police in Verona, identified and arrested the thirteen suspects known to be connected with the theft. Among those arrested, nine were in neighboring Moldova, and three were arrested in Verona. The last member of the group to be arrested was Francesco Silvestri, the security guard who was on duty the night of the theft, hired by a security agency and contracted to keep the museum secure. This would explain the thieves' knowledge of the security

system and their ability to enter through a side door mere minutes before the alarm system was activated, while immediately subduing the security guard. In total, seventeen paintings were stolen, estimated to be worth between $11 million and $17 million. These paintings included works by Peter Paul Rubens, Bellini, Pisanello, Mategna, and Tintoretto.

Museum staffing is something that needs to be reviewed closely, but it is not just employees of museums that take valuables. A French electrician was tried for concealing 271 works from Pablo Picasso. The electrician, Pierre Le Guennec, claimed he was given the works by Picasso as a gift while he worked for him around 1970. In total, the value of the 271 works was estimated to be between $67 million and $112 million. The French court ordered Guennec and his wife to return the paintings to Picasso's family, and they were given a two-year suspended sentence. Quite a payment for an electrician's trade! Picasso must have thought very highly of his electrical skills.

There are museum institutions associated with universities that build facilities solely as a historical archive, or as a display of artwork and artifacts. Many universities will have small museums built as part of the campus. Here they display archaeological finds that can be attributed to the university, or galleries that display famous works of art. Students, without having to leave the campus, can learn a lot by having access to such historical and great works.

In another instance of a theft from a university, a Chinese librarian admitted to stealing and forging a number of works of art in July of 2015. Xiao Yuan, who oversaw the fine arts gallery within the library of the Guangzhou Academy of Fine Arts, stole a total of 143 paintings over the course of working at the library by replacing them with his own fakes. Xiao would go on to sell 125 of the paintings in auctions, amassing a profit of 34 million Yuan (US$6 million). The remaining paintings were estimated to be worth more than 70 million Yuan (US$11 million).[5]

Xiao partially justified his actions stating that when he started his job, he could tell that some of the paintings that were hung were clearly forgeries. Even as he was replacing the paintings with his own, he said he could tell his forgeries were being replaced with other forgeries. The paintings in the library could be "checked out" just like the books in the library; the access and security of the works was disastrous. Both profes-

sors as well as students had complete access to the paintings, and stealing and replacing them was extremely easy. Xiao did announce his deep regret for his actions during his hearing.

It is easy to see the roles museums and university galleries play in a country's economy. These museums care for historical documents, archive famous artifacts, contain and preserve some of the most beautiful works of art, and display them for the communities to view and truly appreciate. These locations play a vital role in the display and preservation of culture, as well as providing a landmark and a location for tourist attractions. On its website, the American Alliance of Museums (AAM) states that museums in the United States directly contribute over $21 billion a year to the American economy. More billions are accumulated each year as well through indirect sales and contributions from museum visitors. The AAM also states that 78 percent of United States leisure travelers are participating in cultural heritage activities. This further illustrates the importance of museums and historical institutions on our overall economy.

Unfortunately, with the increase in international travel, and the larger impact this brings to the economy, these locations are marked as ideal targets for those with the motivation to damage a country's economy and culture. When both local and international visitors are targeted, terrorists achieve their goals by attempting to influence a country's politics through terror. If a popular tourist museum is targeted by terrorists, it can cause massive damage to the country's infrastructure. A violent attack will not only damage the cultural icons displayed within, but it can also prevent access to the museum by regular transport. Fear of terrorism discourages tourism to these locations from other countries.

An example of this form of cultural warfare took place in Tunisia in March of 2015 when the Bardo National Museum in the Tunisian capital city of Tunis was attacked. Twenty-one individuals were killed.[6] Five were tourists from Japan, four were Italian, two were Colombian, two from Spain, and one each from Australia, Poland, and France; the rest were either unidentified or Tunisian. The Tunisian prime minister went on to say that at least forty-four people were injured, including tourists from Italy, France, Japan, South Africa, Poland, Russia, and England, as well as civilians from Tunisia. Some officials stated that the attack took place shortly after authorities had seized a large amount of Jihadist

weapons and guns, leading to speculation that the attack was retaliation for the loss of weapons. Days before the attack, a known Islamic (ISIL) leader, Abu Zakariya Al-Tunisi, had been killed, leading to even more speculation at a connection. ISIL later claimed responsibility for the attack, further solidifying the belief that the attack was an act of terrorism.

The attackers of the Bardo National Museum managed to severely stunt tourism travel to the country. While Tunisia is known to be a source of Syrian fighting, the attack created a ripple effect in the region. Tourism was hardest hit from the attack; due to the fear generated, many potential tourists canceled their visits. Another aspect of this type of attack is the spread of fear and the increase in terrorist groups' actions on an international scale, usually the result of retaliation against those fighting against their cause. Terrorist groups use this fear to keep countries and militaries from wanting to take action against them and to further their cause by showing that they willing to go to any length to justify their actions. Targeting a cultural building also destroys the cultures of countries that may disagree with the ideals of the terrorist groups.

We have stated before that the groups ISIL and ISIS are currently committing these types of cultural warfare throughout Syria and the Middle East. Cultural sites and historical icons are being targeting by the group. These locations are being targeted because they display a cultural identity and a history that the group disagrees with; these locations are looted for valuable artifacts and then completely destroyed. The artifacts are then sold online to provide funding for the groups' actions. Often these looted items are bought by wealthy collectors from all over the world, especially within the United States.

Museums are an important aspect of our economy, as well as our cultural identity, and act as a method of preserving, protecting, and displaying our historic artifacts and irreplaceable artwork. These institutions and organizations, while being invaluable to the preservation of cultural heritage, also represent an issue of security making them a convenient target for those wanting to cause extensive damage and fear. It is important to take into account the security issues that museums face on a daily basis, not just from a law enforcement standpoint but also as a visitor. Museums rely on the monetary support of members and visitors, and if more people were vocal on the matter of security,

changes could be made. Museums are built for the community that surrounds them, and as such the visitors are the ones who can push for different policies to promote change where it is needed. Many museums will forgo a proper security system in an effort to acquire new and better artifacts and displays. A visitor can take steps to ensure that they are not part of the problem in encouraging the museum to do this at the cost of protecting the work already within the walls of the institution.

9

POLICE DEMANDS, SCRUTINY, EDUCATION, AND THE FUTURE

The American law enforcement system—the local, city, and state police departments—have been under heavy scrutiny in recent years. The police are criticized for being overly militarized, racist, and having an unbalanced number of Caucasian officers and civilian personnel in departments rather than numbers that reflect the population of the cities they protect. The consequences from recent police-involved shootings, and the disproportionate number of minorities in prisons, results in distrust toward the entire law enforcement system. It is important to mention these aspects of American law enforcement because these topics are inextricably intertwined when considering the importance placed on day to day policing rather than that of art crime.

There is a certain personality type that is drawn to policing as a career. Generally speaking, the cultural backgrounds are often stereotypical, as well as fairly uniform among police departments within the United States. In many cases departments are filled with officers raised in middle-class families and with fairly conservative mind-sets. Although it would be incorrect to say all officers follow a conservative political ideology, it is safe to say police are conservative in their views on right from wrong. It is not unusual for the same families to have military experience and strong religious beliefs. Often these men and women come from law-enforcement families or those who work in trades. It is safe to say the police officer personality believes in hard work, not "handouts," frowning upon people taking advantage of the

system. Regardless of the personal beliefs of police personnel, officers respect the order the legal system offers and work to preserve the system they believe is for the best interests of society. Personal beliefs are often put to the test when officers deal with the criminal element. Police either do not cope with the stress of the job well and leave for other employment, become jaded, or so set in their personal values, it is difficult to consider other perspectives and ideas. When police go to work, they make daily decisions that send people to prison and put their own lives on the line to ensure the safety of others; while doing so, they are consistently scrutinized by the public. To be a good police officer you must know that your decisions are correct based on the laws and people's rights as outlined in the Constitution. When in court, police testify to what they have seen, heard, and done based on their knowledge of the law as well as their experience and expertise. Some may consider this a mind-set of someone who believes they are always right, and that is probably a true characteristic of a good police officer. If you are not confident in your decisions, you lack the skills necessary for this job. Along with the trait of always being right is the long history of a strong "macho" attitude. The police system is primarily dominated by men. They strap on Kevlar bulletproof vests every day, drive heavily equipped cars, and carry a number of different weapons and tools of the trade. Depending on the area where they work, officers may find themselves involved in physical altercations on a daily basis, or they must consistently deal with the same unsavory individuals. Police develop a thick skin to maintain their mental health while bringing a presence of authority to any situation. Their authority is constantly challenged, which forces them to bolster their own confidence; they may run the risk of presenting themselves as overly masculine, which can lead to excessive force or violence. There are healthier alternatives for maintaining their mental and physical presence; for example, by distancing themselves from the masculine aspects of the job, utilizing verbal de-escalation tactics, and employing community outreach techniques. Healthy departments are determined by the leaders of police agencies. It is the chief of the department that sets the tone for the rest of the officers.

When it comes to art crimes, American law enforcement, particularly at the local and state levels, mirrors public perception by the fact that they are largely unaware of the severity or scope of art crime and its

connection at the global level. The reasons behind this can be attrib-
uted to American cultural values, the media, the prevalent crimes offi-
cers deal with on a daily basis, what they can reasonably accomplish,
how the officers are trained, and the types of men and women who
enter the law enforcement profession. Clearly the issues facing law
enforcement stem from more than a few factors, and in order to appro-
priately deal with the different aspects of crime, the law enforcement
system must evolve with the times while, at the same time, prioritizing
education and training requirements. A department's primary concern
is management leadership, their relationship to their communities, and,
finally, the connection to their officers. Secondly, managers need to
critically examine education, training, and police perceptions in relation
to the rest of society. Are a police department's hiring practices based
on finding the best and most diverse candidates using the most effective
psychological testing and extensive background investigations of candi-
dates? Some police agencies have an excellent hiring process, whereas
others are significantly less stellar. Psychological testing cannot deter-
mine what racist opinions and biases an individual holds, but there are
effective methods used to enlighten students in educating against ra-
cism. With the troubling news reports of police-involved shootings and
the retaliation of a small group who are targeting and killing officers,
police training must be reviewed to bring awareness to police on the
tactics individuals or groups use to kill officers. On the one hand, when
reviewing shootings across the United States, we do not know that the
majority of deaths of black people are committed by blacks them-
selves.[1] There is no evidence of disparity in the number of police shoot-
ings of African Americans compared to police shootings of whites be-
cause the FBI does not as yet collect these statistics. The FBI has
recently requested that the demographics for those shot in active police
shootings be added to the Uniform Crime Reporting Program (UCR)
for accurate statistical purposes.[2] The race issue is a social and political
reality that needs work, effort, and understanding; it will not go away on
its own. Aside from race issues, there is a portion of society that will
never accept these statistics and others who will never accept equality.
Reaching citizens on both sides of this problem will take time and
education as well as a police force made up of cultures that reflect the
community. Another threat to police are homegrown terrorists. The
following examples exclude the names of the killers to downplay the

notoriety they wished to gain through their horrific actions. Instead, we ask that you consider the victims who are too numerous to name. Examples of homegrown terrorists include the Virginia Tech college shooting in 2007 where thirty-two people were killed and seventeen were injured, the self-professed Islamic terrorist who killed forty-nine people in an Orlando nightclub in 2016, and another who bombed the federal building in Oklahoma in 1995. Closely connected to the politics of the Oklahoma bomber are the Patriots and Sovereign Citizens, two organizations made up of anti-government, pro-militia, and right-wing groups who do not believe in the legality of the federal government. They do not recognize the authority of law enforcement, other than local sheriffs, and are considered dangerous by the police because of their violent history. The members are affiliated with the Branch Davidians, the group from Waco, Texas, that fought and died after facing off with several federal agencies while holed up in their compound in 1993. The fight ensued when the group's leader refused admittance to law enforcement, even though the latter had a warrant to search for weapons violations. Public opinion was opposed to the handling of the Waco standoff after seventy-six people died in the battle and fire that consumed the compound. [3]

These are but a sampling of the homegrown terrorists confronting law enforcement in America today. Terrorism investigations were once the sole domain of the FBI, but now they cross jurisdictions between federal, state, and local agencies. The sharing of information and work-related joint investigations between federal and state and local agencies is purportedly better than it was prior to 9/11. Street officers are required to respond to every call their agency receives and follow up with investigations when needed. Since 9/11, the tasks assigned to police have increased and they are expected to be the first line of defense against terrorism at the street level; hence the military-style uniforms and more intimidating vehicles passed to police from the military. There is much debate on officer safety, particularly in regard to the military-style equipment they are being provided. While the military equipment is detrimental to the community relations aspect of policing, it is in place to protect the officers' lives. An officer's death means the possibility of further loss of life, including the possibility of the officer's own weapons being used in other crimes. When you consider all of the

pressures on police agencies, art crime, although important, does not stand at the top of the list of funding priorities.

The officers on the street deal with a wide variety of issues from physically fighting a violent offender, to assisting in medical emergencies, conducting routine traffic stops, investigating murder and suicides, or stopping to play basketball or baseball with children on the street. As such, the officers themselves need to be well rounded and able to adapt quickly to face whatever issues arise. Unfortunately, this also means that few officers are trained to be specialized in specific areas. Some officers will go on to be investigators or work in tactical or specialized drug units, but the majority of officers handle whatever society throws at them. This career has to be the most bipolar profession in America today. Police must expect to be hypervigilant, anticipating violence and the possibility of being shot when stopping or interacting with the general public; while at the same time, the public consistently demands service-oriented officers who are kind and helpful to everyone. When there is an error in judgment, or a mistake is made by the police and the officer is responsible, the result varies from a jail sentence, being terminated, demoted, forced to quit for medical reasons, or alienation on the job by fellow officers. How then, do we interest our officers in taking art crime more seriously when they are pulled in so many directions?

Community policing focuses on outreach programs in an attempt to smooth relations between the police department and the community. Officers are expected to transition between these two modes quickly and seamlessly. In an effort to respond to the extreme street violence faced by police officers, more research is being conducted on the physical and mental training of officers. The Force Science Institute is one such influential research center. Headed by Dr. Bill Lewinski, the Force Science Institute studies the physical and psychological influences on officers in high-stress situations. Using a scientific approach, the institute examines behaviors exhibited by officers in high-stress, confrontational situations and recommends alternative training to offset negative outcomes.[4]

Other police research focuses on a variety of investigative methods, hands-on tactics, use of force, legal framework, pursuit driving, firearms, and stress-management techniques. The major research groups for law enforcement place a heavy emphasis on research involving tactical maneuvers and the stress associated with violent encounters. An-

other teaching tool is tactical mind-set, where the officers are trained to be on guard, to be aware of their surroundings, and to react to any threat to either themselves or to others. Much of the public do not realize the stress this transition places on an officer's psyche. The officers are put through rigorous trainings, one of the most effective being "scenario-based training" or "reality-based training." In these training situations the officers are given guns with paint rounds, along with their normal equipment. They go up against "actors" in simulated scenarios. The instructors create these scenarios, attempting to be as realistic as possible; they are looking to trip up the officers or force them into extremely difficult situations. The officers are often attacked by the actors, forced into ground combat, or have to quickly identify the possibility of a weapon and determine the appropriate reaction. These decisions take place in seconds. The sessions are recorded and reviewed so the officers can better understand where they could improve. The majority of the general public have unrealistic expectations of police officers and believe their training prepares them for everything. This is shown in a court case where the jurors believed the officer should have been able to see if there were bullets in a revolver that was pointed at the officer.[5] Obviously the jurors had never been in a life-or-death situation with a gun pointed at them. If they had, they would know the only thing they would remember is how very large the size of the barrel appeared. The last thing an officer is doing when faced with a revolver is trying to count the bullets. This is not realistic or compatible with the natural reactions of a human being.

The more mundane reality is that officers don't see art crimes as anything more than a property crime. To them it's just another theft, albeit a theft with a much higher-than-average price tag. The officers tend to focus on more "pressing concerns," those crimes that in their perspective directly affect the safety of people. The pressing concerns or major crimes are those commonly followed by the media—homicide, human trafficking, drug abuse and drug trades, illegal firearms, sexual assaults and other violent crimes, burglaries, terrorism, and so on. The seriousness of these crimes certainly cannot be discounted, and police departments with a large number of calls tend to be more reactive than proactive, having to make decisions about the order in which calls will be handled. Crimes against persons are given priority, followed by crimes against property. In our society, human life is always primary

and material wealth is of lesser importance. This is not a function of police overlooking "lesser crimes"; it is a matter of logistics. Police departments are a service to society; however, as with business, they are under monetary and time constraints and focus on the most pressing crimes. Crimes against property—including art crime—are not viewed as being as serious or detrimental to society as the ones that can be directly connected to injury or loss of human life. What can be changed is the law's perspective of art crime and the damage it does to society, which could be raised from a theft to a more serious crime.

What officers have not been educated on is the fact that art crime, on many occasions, is linked at the street level to the global level, connecting art and antiquity theft to fraud and terrorism and international criminal organizations. Following 9/11, it took time to educate the officers on the numerous crimes and threats of terrorism within their own communities and to link these crimes to the international level. With art crimes, the same learning curve needs to take place; how officers view the art world needs to change. Because of the high price tag associated with an individual item of art, police may feel that the art world is beyond the scope of what they can relate to or what their duties entail. Even the institutions portray themselves as overly extravagant, building on the hype of the product for view or for sale. The expense and persona of the art world is viewed by the lower and middle classes as beyond their reach, and for this reason, out of the realm of the average police officer's investigative know-how. Because of the middle-class or blue-collar "macho" attitude that so many officers develop through the job, the "high class" society seems largely unrealistic. This could be largely attributed to the "American Dream" mentality, strongly enforcing the idea of working and laboring for a living. Educating officers is a powerful tool, and increasing the requirements for education is a means of overcoming the class distinction between the rich and middle class. Acknowledging that the rich are also capable of committing criminal acts, and they are no different than other human beings, teaches officers that wealth and social status must not influence their decisions.

Local and state law enforcement agencies are increasingly searching for applicants with law enforcement education and look far more favorably on those applicants who come from a military background. Law enforcement prizes those with military experience, with the under-

standing that they can take orders, adapt to the command structure, and handle high-stress incidents. While military experience is extremely beneficial due to the previously mentioned reasons, it also has an extremely negative side effect. Many of these officers lack the ability to think outside of what they are told. They are so accustomed to taking orders without question that they lose the ability to think creatively or consider the reasoning and logic behind their daily interactions with the public. Those who are taught to take orders are not taught to be creative thinkers.

We seriously promote the hiring of law enforcement with a greater background in various areas of education. When education is at its best, it provides the student with the ability to think critically on subjects with which they may not agree. An educated officer can avoid the stereotypical mind-set, step back, and consider other viewpoints. We believe that there are more opportunities for officers who are capable of understanding a stranger's perspective. Avoiding blind adherence to training allows an officer to negotiate and relate to any individual, preserve an individual's rights, and find a solution other than force to resolve a situation.

In the past many departments scoffed at the idea of hiring officers with higher educations; the belief being that they "think too much," making it harder for those individuals to make quick decisions because they are bogged down by the different options or consequences of each individual action. Looking into students with other majors is also considered unhelpful. The idea of having an art major or a philosophy major as a new hire for a police job is considered ridiculous—the thought process being that they won't last or be able to handle the job. The educated are viewed as being metaphorically soft, as a marshmallow, and when the heat of the high-stress job hits them, they will melt and fail to perform. This "old boys'" attitude is changing, probably the result of the intimidation factor when new officers hired by the department were better educated than their superiors. For example, an article from the *Houston Chronicle* found the minimum qualification for a chief of police is a baccalaureate degree. The article equates the chief job with that of a corporate CEO of a business.[6] In 2006, I interviewed American and Canadian chiefs and upper administrators for my dissertation on the effects of 9/11 on policing. I was impressed and surprised to find the smaller agencies' managers and chiefs held a baccalaureate

degree and those in larger departments had either a masters, a PhD, or equivalent. It was obvious during the interviews that the interviewees were extremely bright and very political; some leaders were well ahead of their time, displaying an ability to adapt to change and a willingness to make their police agencies world-class. As with any organization, it is the leader that determines the perspective and direction of a police department.

Departments often conduct personality testing in order to find out more about their new hires before they enter the department. The departments set up specific criteria for the type of officers they want. In many cases, they use their current officers' personality tests as a guideline for who they should continue to hire. The justification for this is to find officers who will seamlessly fit into the community as well as the department without causing any undue stress to the officers. Unfortunately, the departments are not gaining new officers with different mind-sets and ideas. The conservative, blue-collar, middle-class stereotype continues to persevere within departments because of this inability to adapt and change. If departments accept officers with different backgrounds and different personalities, they will gain new perspectives and discover a variety of solutions to problems both old and new.

Another shocking aspect related to personality testing in the hiring process is the use of IQ tests. Some departments have gone so far as to conduct IQ tests on the new hires, and if those officers test too high, they are eliminated from the hiring process. The idea is very similar to the view on higher education—officers wouldn't be able to make rapid decisions in high-stress situations. A more prevalent argument is that officers would become bored with the job as a street officer and quit. Attrition is expensive for departments, so they want to hire officers they believe will stay.[7]

When departments are made up primarily of the same types of individuals, these departments stop seeing anything outside of their own narrow mind-set. The contribution from the more creative individuals would only enhance an officer's ability to interact with the public and to conduct investigations. There is a particular investigative approach that could be augmented by officers with different interests, education, and backgrounds. Having a creative mindset, or a background that differs from their fellow officers, allows the officer to come up with different solutions and different perspectives. This has been proven in studies

that show the differences between the way men and women communicate and see things, which can strengthen an investigation. Why then would an investigation not profit from broader mindsets?

There is one common justification for having officers with different backgrounds: to fulfill specific job areas. Persons with different backgrounds are put into specific and limited fields—officers with art and drawing backgrounds are used as sketch artists, those with science backgrounds become forensic specialists. The idea of creative thought isn't highly valued within the departments. The training the officers are provided is under the idea of "this is the best way," and the officers are rarely given an option to come up with different approaches. The command structure within departments usually doesn't allow for much questioning or original thought. While this militaristic approach is extremely effective for high-stress situations and creates better accountability, it does not allow more creative approaches or enable officers to fully understand a variety of crimes. By discouraging an open-minded perspective—which could allow an officer to see what more "traditional-minded" officers might fail to notice—an investigation may be hampered.

The ongoing training that officers do receive is focused on a number of factors. Hands-on tactics, and by extension unit tactics, stress risks to the officers; and investigation methods are some of the primary courses offered to officers. Officers can train in more specialized fields—such as forensics, advanced tactics, negotiation techniques, and many others—but only at their own expense or when petitioned from the department, which is not always guaranteed. Two-year colleges that target law enforcement are focused on a technical perspective rather than an academic one. The idea is to produce graduates who will become police officers rather than producing graduates who will advance the field of police work itself.

This problem within colleges isn't strictly limited to law enforcement, but many other areas as well. Whereas undergraduate studies once focused on academics and turning out graduates who were freethinking individuals, it has now become focused on producing graduates who will simply get jobs. This comes down to funding at its most basic level. Four-year colleges are judged by the degrees they confer within the four-year time line and the jobs the graduates receive after college. Colleges are encouraged to push their students through in a

timely manner and to attract more and more students. College funding in the United States is tied to President Obama's initiative to increase the number of student graduates of color and to graduating all students in a timely manner.

Departments that do not require their officers to have college degrees have entry academies in order to train the officers. The training received is far from standard and each state has its own Police Officer Standardized Testing (POST). The requirements vary dramatically, with some requiring a college education or military experience, while most states simply require a high school degree or a GED in order to qualify. Beyond the qualifications for the job, some departments may focus heavily on the use of force tactics, while others will focus on community outreach. The methods and ideas change based on the community it covers. Lower-income areas tend to produce departments that are more reactive, use less community interaction, and are geared toward use of force; upper-income and higher-educated areas will focus more on community outreach and political correctness. Departments' methods of action on the job are a reflection of the training the officers receive. The training and the department mind-set are also directly affected by the community's relationship with the department. Ultimately the mind-set comes down to fear—fear of the community's actions toward the department and fear of the damage the politicians could cause toward the department and the careers of those employed within.

Regardless of whether the department is large or small, reactive or proactive, explaining to police how art crime is interconnected to looting, fraud, and money laundering from drug sales and other illicit activity is a good place to start the conversation. Police are trained to spot clues that determine if drugs are being transported on the highways. Further education is required on what to look for regarding the transportation of illegal items such as art. To emphasize the importance of art crime, officers need to learn the connection between the drugs on the streets, manufacturers and importers, and how the money is laundered using art. They also need to be educated on the connection between tax evasion and the selling of illegal art and antiquities to fund terrorist groups and organized crime. More states now require higher education, and police officers on the street are not as stupid as some might suggest. Direction or enlightenment on the subject of art crime

will open the eyes of officers who will begin to make connections with what they see on the street with what does not "feel right."

Art crimes take more time to investigate and until changes are made to the importance placed on art crime, departments will not spend the time or money. What we are recommending is a separate category in the Uniform Crime Reporting (UCR) document that is completed by police departments and sent to the FBI. The UCR categorizes crimes in terms of importance, starting with murder and working its way down to minor property offenses. Art crime needs a category of its own that is higher on the list, moving it to the top of property crimes. Finally, all law enforcement organizations share criminal information with other agencies. Information that crosses jurisdictions is also sent on to the FBI, ICE, or Homeland Security.[8] In the same way, entities at the federal levels share criminal typologies with businesses and industries that terrorists and criminal organizations seek to exploit. Sharing of information is vital between the street level to the state and federal levels just as it is vital to the federal levels to share with business and trade to protect against the more sophisticated criminal deception.

10

WAYS IN WHICH LAW ENFORCEMENT CAN FOCUS ON ART CRIMES

We have discussed at length why the majority within the American law enforcement system does not appear to have the same interest in art crimes as they perhaps should. Even at a national level, the crimes themselves are reported under the broad category of "property crimes" within the Uniform Crime Report (UCR), lending even less merit to art and artifacts as something of cultural value and more as a monetary value, or simply as an object. The UCR is the official listing produced by the FBI that provides the statistics of all reported crimes within the United States. The disregard for the theft, neglect, and destruction of art can best be seen as a type of cultural misunderstanding. The law enforcement system is in many ways a reflection of our cultural values and behaviors. Refusing to examine art crimes more seriously is certainly a reflection of who we are as a country and culture. This very same criminal justice system sees our worst examples of greed and lack of humanity, which arguably can be the truest form of who and what we are as a country and a culture.

Rather than bemoaning the fact that American law enforcement does not particularly care or focus on art and cultural crimes, we instead choose to focus on a variety of ways to improve appreciation for the subject matter within that law enforcement community. Then we focus on their ability to properly investigate and combat these crimes, which rank so highly on a global scale. Simply learning to view art and artifacts as a cultural representation can lead to appreciating the works. Taking

further steps to understand artwork through education can go a long way in aiding this effort. Outside of knowing about the individual works, and the styles and histories, it is extremely important for those investigating to have an understanding of other laws and cultures in different countries and departments.

The federal agencies within the United States have taken steps to better combat art crime by taking the field of art crime more seriously. The FBI has a small art crimes division, and ICE deals with a great deal of the artwork coming into the country as well as leaving through customs. Homeland Security takes the lead in investigating criminal distribution of cultural property and recovery efforts of art or artifacts that are reported as lost or stolen. Internationally Homeland Security has sixty-two attachés in forty-six countries. Through these connections, they work on joint investigations with foreign countries. This is a joint endeavor of both domestic and international police to investigate and recover trafficked art and antiquities[1]

The American federal agencies have a broader understanding of the issues at the international and federal levels but do not have the ability to completely handle the issue within the country on their own. Ultimately, it comes down to assistance from the local and state-level police departments when they discover and investigate the theft or abuse of art and culturally significant artifacts at the street level. It is not that the local departments do not already contact Homeland Security when they have an art-related crime, but there are a number of potential clues that may be bypassed or ignored due to a lack of understanding. Federal agencies do not have the personnel or resources required to properly handle the issue. Considering the size of the United States, art crime divisions are in contrast considerably smaller than many of the agencies in Europe. Due to the limited number of trained federal agents investigating various art crimes, it is of vital importance for street officers to be cognizant of the severity and instances of crime affiliated with art and to know to consult with agencies who oversee these crimes.

One of the major concerns that is often encountered: when a federal agency or a larger department is brought in, or comes in, to work a crime that began at the local police level. In many ways this will make the initial investigating officers feel like they are being walked over or pushed aside—the investigation taken out from under them. Officers who work cases tend to want to see them to completion. It is a natural

part of an officer's mindset and assists them in solving cases, as well as adding to the overall satisfaction of their work. After all, we wouldn't want police officers on our streets who are willing to just let crimes fall through the cracks without being solved; we want our officers to be driven by this need to solve whatever crimes they may face. However, when another agency is brought in to take over the investigation, that officer loses his or her access to information or resources that may lead to important discoveries. There is also the perception that the larger agency is only coming in because the case is high profile and would make their agency look more favorable in the public eye.

Many local officers are also under the belief that the federal agents will only take cases that they know will win in court. Therefore, if an officer is conducting an investigation, and an agency comes in to take over, the officer will interpret this as their success being taken away from them. Within law enforcement, success is often gauged by closed cases and legitimate arrests. When an agency takes over a case, and the officer is under the belief that the agency only conducts investigations on what they know they can prosecute, the officer's hard work and effort toward the case is now under another person and another agency's name. While the ultimate goal is to find justice, officers are still human, and will feel slighted if they do not receive the credit they feel they deserve. One of the failings of the system prior to 9/11 was the inability or reluctance of law enforcement agencies to work with one another or across state and federal lines. Officers recognize this fact and accept the limits of their authority within the judicial system but it does not make it any easier.

With the considerable dollar amount attributed to the many different types of artwork, as well as the extensive media coverage, recovery of said artwork is easy to publicize. When the work is not recovered, it also creates a black mark on the investigator's history. In order to see examples of this, we only need to look at the FBI's art crime team. Many of the successful investigations and recoveries are proudly displayed in the news and on their website; that in turn, creates a great deal of public support for the agency. The FBI does advertise the negatives of the art theft investigations; for example, by consistently showing images of the Gardner theft, they hope to find a clue that could lead to the recovery of the works. In many ways this represents the continual

effort of law enforcement agencies as they take the time to simply wait and watch for the stolen works to resurface.

Due to the high value placed on artwork, there is considerable interest from insurance companies. Many officers find it extremely difficult to work an investigation while also cooperating with an insurance agent or an investigator working for a private party. An officer may find an outsider's ideals and motivations different from their own, and this can seem threatening: they are an unfamiliar third party who is questioning their interest and expertise in handling the case at hand. The insurance companies are largely motivated by the fiscal aspects, approaching the investigation strictly as a business proposition. Considering the expense to the insurance company, insurance investigators may have a much greater desire to push for a speedy recovery of the stolen artwork. Police, on the other hand, do not necessarily want to share their information with outsiders and fear working together will threaten their chances of an arrest. While insurance companies want to discount the claim and are willing to purchase the stolen item to have it returned, the police simply want an arrest and criminal charges. In an effort to work together, both parties must communicate their expectations, approach, and willingness to share for both to have a successful end, but the reality is the two are at odds in their desired outcomes.

To understand why cooperation with other agencies is so important, and to be more open-minded, officers will need to better understand the ramifications of the crime itself. Police encounter any and every type of crime imaginable, including art and cultural crimes, that may not be recognized as such by the officers. An artifact may appear to be an old piece of carved rock or junk pottery, and a painting may not deserve a glance, but introducing officers to some basic knowledge will alert street officers to take a second look. This is something we hope this book touches upon, recognizing when something that looks mundane may actually be relevant. It would not take much time and effort to educate officers on the wide variety of crimes linked to art that are outlined in this book. Officers' perspectives will change with in-house training or hiring of police officers with broader educations. Once officers are informed, they will look more intently during traffic stops, casual encounters, and other criminal investigations.

If enough interest and attention is generated, departments could easily bring in guest speakers or send their officers to a variety of con-

ferences and presentations to educate their officers on this topic. Museums, universities, and art-related groups have people who are hired and trained to speak to the general public. This service may be free to the police or require a small stipend as payment. How effective this could be is largely dependent on the officers' willingness to accept different ideas that may vary from their own personal beliefs and biases, as well as those ideas that run counter to police culture. This perspective of being open to new ideas may be one of the most difficult steps for law enforcement, considering officers tend to develop their habits through their training. A side effect of the police training and the militaristic mindset forces officers to become set in their routines. Their physical training, for instance, is designed to instill automatic reactions, to respond as they have been trained—not to stand there thinking about what to do next. We have discussed the lack of interest in officers adapting to different ideas and new perspectives as a natural reaction to the requirements of the job. We cannot stress enough how this mindset of law enforcement needs to change—in the officers as well as the administration and training organizations. This is done with continuous education and training, not only in the most recent physical and technical in-service training but in broader social and artistic topics. Through the use of additional training, or having experts in the area of art and cultural crimes come in to departments to brief officers, they would be made aware of the severity of art crimes. The officers can be introduced to the various instances of art crimes that have been committed. We recommend using the dollar amounts attached to the thefts, as well as the known links to terrorism, money laundering, and fraud to further impress the importance of the matter. By reviewing thefts, as well as viewing the investigation reports, the officers will not only learn of the severity of the issue but will also be taught a great deal about how the thefts are conducted and executed.

Higher education, not surprisingly, can go a long way in assisting the continual exchange of information and ideas. For those willing to learn, further education will expand their thinking and broaden the perception of information they encounter. We have stated previously that some police departments are starting to require their officers have some form of higher education. This ensures that the officers being hired are able to think in new and different ways. While a higher education beyond a high school degree does not always result in more flexible

thinking, it certainly assists in the effort. Continuing education and training works to alleviate the narrow mind-set that officers acquire after four to five years of patrolling the streets.

While officers on the street are not educated in art and cultural crimes, those who dominate this area of study are primarily scholars, whose focus is on art history and archaeology. The academics with this expertise have no concept of policing and cannot relate to the job of officers on the street. This is a profession that cannot be fully understood without experiencing riding in a cruiser and participating in the day-to-day interactions. As such, we need dedicated courses on the subject of art and cultural crimes in colleges and police training programs. Considering the uniqueness of the subject, and the number of areas it branches into, it is a much deserved subject requiring further study and research.

This area of study is appropriate as a minor for law enforcement studies. Students studying to become police officers are often advised to get a minor in another area to assist them in their career; if they are not happy in policing, they have an option at a second career choice. Although this degree may seem obscure, when you consider that art crime and fraud is the third-highest annual criminal grossing income in the world, this area of study is highly appropriate. Further studies for students may be found at the Association for Research into Crimes against Art in Italy or through the University of Glasgow, Scotland, which offers post-graduate, certificates, and degrees for art and cultural crime, applicable to those interested in a career in both art and policing.

When officers are made aware of how these thefts are conducted, they can better recognize the signs when an art theft occurs, and from this point shift their gaze and investigation procedures to approach the crime. If the officer arrives at an alarm call and finds that paintings are missing, it would be extremely important for that officer to immediately identify local experts who would have knowledge of the paintings that were stolen. In another type of incident, if an officer investigating an entirely separate crime finds artwork that seems out of place, they should contact an expert in the area to identify the type of art they are dealing with, as well as to determine if that artwork is stolen, possibly forged, or implicated in a fraud.

A perfect example of police who followed these steps occurred when an officer with the Albuquerque Police Department in New Mexico

recognized artwork that was out of place and contacted an expert who was able to assist the officer. The officer was conducting a routine sweep of a block of condemned apartments previously used to produce methamphetamine. The officer came across art prints that looked out of place compared to the other things in the apartment. Based on knowledge of the previous tenants, and the types of objects they had in the apartment, the officer suspected that the prints had to have been obtained illegally. Taking the appropriate steps, the officer took the prints to the Albuquerque museum and had a curator examine them. The prints were identified as the work of Native American artist Al Momaday and worth approximately $30,000. The police suspected that the prints were stolen while on loan or while the previous owner was moving to a new residence. [2]

The officer could have just logged the prints into evidence and not taken the time and additional steps to investigate further. A great deal of evidence is logged into police custody and will remain there for a set period of time, at which point it is auctioned off or destroyed. Many police departments have a required length of time for which they must hold evidence should the case be reopened or reinvestigated. Considering the prints were not directly related to the investigation the officer was conducting, he could very easily have taken the quicker route, logged the prints, and left it at that. By taking the extra time and care to question why the prints were present, the artwork was successfully recovered and linked to another investigation.

Officers who are trained in different kinds of art crimes would be familiar with the modus operandi of a number of thefts of artwork; they would recognize that some of these non-traditional styles of theft should, in fact, be treated more like a kidnapping. The investigation would be handled differently than conventional criminal investigations. In these situations, officers would determine if the institution was withholding information that could help the case. For example, if a museum reports a break-in or a triggered alarm but then tells the responding officer that nothing is missing, the officer should be suspicious. The officer should trust their instincts that something is amiss and delve further into the issue. When a museum receives a monetary demand for the safe return of a work of art, they may want to mislead authorities to appease the thieves.

By treating the incident as a kidnapping, officers can better understand the significance and unique nature of an artwork. It would greatly benefit officers to receive training in, or to at least be familiar with, a museum's organized security measures. By studying the institution's security system, the officers and investigators can evaluate its weaknesses as well as its strengths. In this way, the officer can identify the extent of time and effort that went into the crime that took place, as well as create a possible list of suspects. This would not be difficult; in the more progressive police agencies, officers are assigned to specific areas, often community based, and must familiarize themselves with the main buildings, businesses, museums, churches, synagogues, and shopping malls contained within, as well as the layouts of the buildings.

Being familiar with the administration and/or the security staff, law enforcement may better respond when an alarm is raised. If they are familiar with the common issues in the security system, they can answer the call based on the frequency of the problem. If the museum has a known security flaw that is triggered easily without an actual emergency taking place, such as someone leaning against the pressure glass, police will know how to respond. Responding to continual false alarms, however, is not a good policing practice; charging a substantial penalty for the faulty alarm calls reduces the number of these calls. When false alarms are reduced, legitimate alarms are readily responded to and taken very seriously. For those who are knowledgeable about a museum, being familiar with the law enforcement practices can only increase and ensure cooperation between the institution and the police that work the area.

This connection with police at the street level connects full circle to the agreement made with the United Nations, specifically UNESCO. This agreement has been signed by countries all over the world and represents the largest organized movement against art and cultural crimes. While this pertains to a global perspective, it is still of vital importance to those in law enforcement and the arts. If a law enforcement officer is educated and therefore familiar with the United Nations and the role it plays in the policies and laws in place internationally, they can better understand the consequences of the crimes and their own role in that network. The local level is often where these crimes are first observed, and where each one of these crimes eventually will bridge to a federal agency or to other countries.

It is common for these types of investigations to quickly become wrapped up in international politics, along with differences of opinion from one agency to the next at an international level. The methods of investigation change radically, as does the ideology from one country to the next. It is almost a guarantee that those conducting investigations will have to adapt to different laws and address new cultural standards, something they will have to keep in mind when being bogged down with the red tape. For instance, a police department from a western state in the United States sent one of their officers to France to investigate a suspect in a murder that took place in their American city. This almost caused a national incident when the French government let the United States know they did not appreciate the police entering their country and breaking their laws by attempting to interview the suspect. France follows the Code Napoleon, which is an entirely different approach to investigating crimes. The prosecutor does the investigation and interviewing of suspects, not the police. For an American officer to show up unannounced in a foreign country and begin an investigation is appalling. American ethnocentrism and pride will jeopardize solid working relationships with other departments or countries. The world is getting smaller and police departments at all levels require an understanding of, and closer working relationship with, other countries' police agencies. Presently students in law enforcement and criminology programs destined for employment in the criminal justice system are encouraged to study abroad to learn about other systems and make close personal and trusted working relationships for the future.[3]

The sale of Native American artifacts and items in foreign countries illustrates different countries' ideologies and how this difference interacts with art and cultural crimes. While the sale and trade of Native American artifacts and artwork is a very serious crime within the United States, other countries, such as France, take advantage of those same laws and make the sale legal. While the United States maintains an agreement to return any stolen or looted artifacts to France, French laws regarding the sale of Native American artifacts directly oppose this agreement. The sale of these artifacts routinely takes place within public auctions.[4]

While it is legitimate in France, when you consider the issue further, the implications remain that France is taking advantage of looted Native American artifacts. The artifacts are illegally traded outside the

United States' borders to sell in foreign countries. By holding these public auctions and allowing the sale of looted artifacts, France profits by directly ignoring the laws the United States has implemented to protect these artifacts.[5] Not only is the country opposing and breaking these laws, it is also profiting.

The United Nations has taken the important step of creating an overall plan to deal with the issue of art and cultural crimes on a global level. For this reason, it is vital for the countries that signed with the United Nations to take these standards and policies and apply them to their full measure within their own systems. The problem occurs when each country signs the petition, and agrees to the terms; but when it comes to practice, they pick and choose what aspects of the petition they will abide by. This issue does not strictly remain within the area of art and cultural crimes but within international laws as a whole. The United Nations makes great strides in their attempts to create a unified global standard for all countries to follow, but because of its nature, the countries who sign can choose to ignore aspects of the petitions without facing many consequences. The United Nations stands as a convention of the nations of the world, not as a governmental body. In and of itself, these petitions can be enacted through it; however, it is up to the individual countries to enforce the petitions on themselves.

Dr. Amr Al-Azm recommended an interesting perspective on cultural crimes, suggesting that they be classified as terroristic acts. This would draw the attention of law enforcement, giving the crime the status and attention it deserves. This makes sense when one considers the links to terrorism and the funding used for organized crime and terrorist groups. The idea of cultural crimes being a terroristic act is an accurate depiction of the severity and impact of the issue, considering the items are so deeply associated with the damage to cultural identity, history, and human belief systems. The mere fact that the act of destroying and stealing artwork and artifacts is used as a form of cultural warfare should set the issue well within the grounds of a terroristic act.[6]

The identification of art and cultural crimes as a terroristic act would also bring them into the radar of more law enforcement agencies. This change will allow easier classification under a separate category in the UCR. This will make it much easier to track through official crime reports and lend more information to the severity and scope of the crime. It would also greatly benefit the ability of cooperation on an

international level. While the United States and Italy do have an agreement to return any illicit artwork crossing borders, other countries may look toward the United States' more serious stance on the issue and follow their lead. Creating more global cooperation and a cohesive policy to address the problem will ease the negative political aspects of international investigations.

In order to move forward and continue to progress, countries need to want to improve the international community and find solutions rather than attempting to hide from the problems at hand. The United States has in the past stood as a model of combining multiple cultures, and despite the initial reaction to each new culture added, eventually each new addition creates a greater and more adaptable perspective of the country. The continual effort toward intercultural acceptance and cooperation can be directly seen in the effort to preserve cultural heritage and history through art and culturally significant monuments.

11

SECURITY AND POLICING IN ART CRIME THROUGHOUT THE WORLD

To this point, the book has covered a wide range of topics in relation to the policing of art and cultural crimes. Examining each instance of theft, fraud, and destruction, it is clear that several agencies tend to stand out, and their names are repeated throughout the text. Due to the focus on the United States, FBI and ICE are at the forefront of investigations. The other countries mentioned, especially within specific areas in Europe, tend to take the matter more seriously and, as such, maintain far more dedicated agencies toward the issue of cultural crime.

The United Nations (UN) stands as the largest organization contributing to efforts in prevention of arts and cultural crimes. However, by its very nature it cannot maintain a unit to actively investigate and make arrests on the matter. In order to successfully deal with the issue, as per the standards agreed to under the United Nations, the countries within the UN must maintain agencies with the dedicated mission to reduce, prevent, and ultimately find a solution to this growing problem. Italy stands at the forefront of success with the Carabinieri. This comes as little surprise considering Italy's central and invaluable role in the matter of preventing cultural damage, along with its extensive cultural history.

Outside of Italy and across Europe, both Europol and Interpol provide a dedicated presence on the prevention of art and cultural crimes. While both areas provide overlapping coverage, it is certainly a rare and refreshing problem. Beyond that, there are United States agencies, as

well as privately run organizations, that provide training and advice for those in the field of cultural crimes.

The United Nations is the setting for the majority of the world's countries and states to convene and discuss the issues facing the international community. It is an intergovernmental organization, but is not a government or a power itself. The enforcement of the policies set forth by the nations involved is up to the individual nations. While the UN does provide investigative groups that look into member countries that may not be cooperating under the agreed upon policies, the UN can't actually enforce the policies. Enforcement rests with the actual UN member countries that discuss and decide on an action to take.

On October 24, 1945, the UN replaced the League of Nations, which was ultimately found to be ineffective, spurring the creation of the UN. The goal of both groups, in response to World War II, was to prevent a similar conflict in the future. The UN is funded by voluntary donations from its member states. It aims to preserve international peace and prevent conflict, while also furthering economic and environmental goals, along with preventing human rights violations and providing aid in areas when the need arises. As such the UN branches off into a number of smaller departments and specializations in order to ensure that each area is properly accounted for and addressed.[1] As far as art and cultural crimes, the UN has two specific areas that deal with it: the United Nations Educational, Scientific and Cultural Organization (UNESCO), and the United Nations Office of Drugs and Crime (UN-ODC).

UNESCO has been around since 1945, in response to the two massive wars waged within one generation. Among its many ideals, it states that "peace must be established on the basis of humanity's moral and intellectual solidarity."[2] It pursues this goal in a number of ways. A primary role of the group—education for every boy and girl. They also promote freedom of expression as a requirement for any future advancement of human rights. Scientific cooperation is a high priority, such as the encouragement of advanced warning systems for natural disasters. The aspect that ties UNESCO with art and cultural crimes is their work with world heritage, a major function, where they have defined and placed policies protecting sites that are deemed invaluable to universal culture.[3]

Known as the "intellectual" agency of the United Nations, the group fully believes in the promotion of human intelligence and intellect. It is the overall belief that cultures and nations are tied together in this capacity, so the cultural values of one must be upheld and supported by the others. The interconnected nature of the world's cultural heritage cannot be seen as strictly the problem of one country; the destruction and subsequent loss of a cultural artifact or site is ultimately a loss for every culture in the world. This aspect of the United Nations is responsible for the world's policies and practices of protecting world heritage sites, as well as cultural heritage in general.

The UNODC was established in 1997 and is geared toward the prevention of illicit drugs and international crimes. Focused on the increase of attention and awareness to the member states of the United Nations, the program sets forth the policies and laws that should be uniform throughout all the countries. Alternatively, it also encourages member states to be more active and cooperative in respect to transnational crimes. This program creates the ability to have a unanimous standard of law and international cooperation when it comes to what is illegal and legal, lessening the degree of confusion and difference of opinion on legal matters from one country to the next.[4]

To accomplish this, the UNODC is focusing on three missions to meet the larger goals. First it focuses on the member states' ability to address the issues of illicit drugs, international crime, and terrorism by focusing on field-based technical cooperation. Secondly the group utilizes research and analysis in order to further the knowledge and strengthen our understanding of the issues at hand. This research is used as evidence to produce policies and decisions regarding the operating procedures. Lastly, it works toward organizing and assisting the various countries that are willing to implement new and proactive international treaties. As part of these treaties, the UNODC also works toward the implementation of future laws and policies as required.

Moving beyond the United Nations, yet still focusing at an international level, is Art Recovery International (ARI), which stands as a subsidiary of the Art Recovery Group (ARG). The group is a private company with its headquarters in London and additional offices in New Delhi and Milan. It was founded in 2013 and focuses mainly on the recovery of stolen art. By 2015 it had launched the ArtClaim database

(www.artclaim.com/search), which allows for the online access to an image-recognition database for the commercial market.[5]

The company, while not directly a law enforcement entity—or tied to governmental support—does offer its resources and assistance to any law enforcement agency on a pro bono basis. Their resources are also extended to institutions and consumers in the area of art. These specific services range widely but include the research of provenance histories, mediation of title disputes, identification as well as the location of claimed cultural items, and the recovery or negotiation of return of claimed items, to name but a few. The company's staff all have extensive experience in the art research as well as the issues pertaining to international disputes on the matter. This makes it an invaluable tool for any law enforcement agency or independent institution dealing with art crimes.

Considering how seriously Europe takes the matter of art and cultural crimes, it should come as no surprise to find that both Interpol and Europol take firm and progressive actions in order to prevent the loss of these artifacts. While Interpol is not limited to Europe, it is traditionally known to be considerably more active in that area. Interpol does, however, extend across the world, working closely with the United Nations and the European Union. In total there are 190 countries that are considered to be members of the organization.

Interpol is the largest intercultural police organization in the world. This organization focuses on the assistance of various countries within its jurisdiction, under the strict guideline that it will not intervene in the areas of politics, military, religious, or racial matters. This ensures that the organization remains unbiased and will not work contrary to issues that may prevent international cooperation. Additionally, when assisting various countries, Interpol operates within the scope of the laws of whichever country they are operating within, guaranteeing that they do not compromise different countries' judicial systems.[6]

Europol differs from Interpol in the fact that it is specifically focused on the coverage of the European Union countries. The headquarters is in The Hague, Netherlands, and operates with over nine hundred staff members necessary to cover all of the EU countries. Europol does extend its assistance to a few non-member countries such as Australia, Canada, Norway, and the United States. While also similar to Interpol, in the international nature of the organization and having to maintain

the cross border investigation methods, it keeps a strong operating focus. This allows the coordination of law enforcement agencies and staff within the various countries to better approach international crimes that so easily cross the many borders within Europe.

With art crime, Interpol stands as one of the most active law enforcement organizations investigating art crime. While working to raise awareness of the high rate of crime, the group focuses on the data of the crimes themselves. They provide a list of all documented and reported art thefts, the art that has been returned after being stolen, and a list of artwork that has been recovered but has yet to be claimed. All of these services are provided to law enforcement agencies as well as authorized persons or companies. Interpol does not just focus on police and law enforcement; it also highly encourages the cooperation and effort of all art and antiques dealers to maximize the coverage. In the matter of art and cultural crimes, Interpol works closely with UNESCO, the International Council of Museums, UNODC, and the World Customs Organization.[7]

Within Europe, as well as the rest of the world, Italy continually leads in the prevention and tracking of art crimes. This is attributed to Italy's lengthy and cultured history. Being the center of the Roman Empire, as well as the center of the Renaissance, Italy contains some of the most sought-after and prized artwork and artifacts in the world. The sheer volume of cultural history is displayed constantly and without compare. When the question of protecting these works of art arises, Italy has a very dedicated force. The police in charge of this area are known as the Carabinieri, which is both a branch of their military as well as law enforcement.

The Italian Carabinieri is one of the four branches of Italian military. Because it is seen as a military branch as well as a law enforcement entity, it plays a very unique role. Many of the officers are present both in the larger cities as well as smaller villages, conducting routine law enforcement activities as needed. The branch was founded on July 13, 1814, and has since become a well-respected part of the Italian military and law enforcement. Their duties have expended considerable effort in the furthering of international law enforcement cooperation, especially in cases related to Italian art and antiquities thefts and looting.[8]

Officially titled the Carabinieiri Headquarters for Protection of Cultural Heritage, or in Italian the TPC (Carabinieri Tutela Patrimonio

Culturale), the agency actually predates the UNESCO convention on protection of cultural heritage by one year. Created in 1969, the TPC is also often referred to as the Caribinieri Art Squad, considering its role in the recovery of stolen art. The TPC also provides some peacekeeping roles in international conflicts, specifically in the training of foreign agencies of police and customs, in the preservation of archaeological artifacts, and museums and private collections relevant to national heritage. Consisting of over three hundred agents, the TPC provides dedicated coverage to all of Italy, with assistance being provided to Interpol and Europol as well.[9]

England brought about its own area of art and antiquities theft prevention at the same time as Italy with the creation of the Metropolitan Police (Scotland Yard) Art and Antiquities Unit. This unit was created in 1969 to combat the crime accompanying the growing art market within London. The unit primarily works as an aid to investigations and toward raising awareness of the crime itself. It compiles a list of documented artwork, along with current whereabouts, to ensure they are not thought to be legitimately in another's possession. They also keep close ties with local art and antiquities markets to maintain an awareness of the current politics and news surrounding the market they are safeguarding. The unit is not strictly police; it maintains members in a number of different areas, such as museum security staff and art councils.[10]

There are two agencies within the United States that have focused units on art and cultural crimes; these units are within the FBI and ICE. While many of the crimes are initially found at a local level, once there is an association to art crime, these two agencies have the opportunity to involve themselves. Depending on the scope of the case, they could completely take charge of an investigation if it is within their jurisdiction. Considering these are both federal agencies, they can conduct themselves anywhere in the country and, with the consent of foreign governments, follow through with their investigations internationally.

The FBI is the primary policing body for the United States for federal law enforcement investigations. It was founded in 1908 under President Theodore Roosevelt in response to the public's concern with law enforcement, putting it in a "political" position. Now the agency, which handles some of the most serious crimes that face the country,

has jurisdiction over two hundred different forms of federal laws. In fact, on the matter of terrorist activities, once it is discovered that there may be a connection, the FBI immediately has jurisdiction of the case. In addition to investigating terrorist activities, the FBI also handles counterintelligence, cyber crime, weapons of mass destruction, public corruption, civil rights, organized crime, white-collar crime, violent crimes, and major thefts, which include art crime. [11]

The FBI's Art Crime Team was founded in 2004 with sixteen agents. These agents receive advanced training that will benefit them in this specific field, as well as training in foreign law and foreign affairs so they will be well equipped to serve within legal attaché offices. Considering the nature of art crime, it is important that these agents be educated on the legal issues of foreign countries, giving them the ability to follow investigations across borders. The United States Department of Justice also provides specialized attorneys to the Art Crime Team; these attorneys specialize in art crimes and provide a much-needed legal background to help the agents conducting investigations. [12]

At the time of this book, according to the FBI's website, the Art Crime Team has successfully recovered over 2,650 missing and stolen items, amounting to a value of over $150 million. [13] Some of these recoveries come from low-key, simple theft investigations involving museum employees or art collectors, while others involve interagency sting operations comprising years of work. In many cases the international cooperation is of vital importance, and the FBI will operate alongside foreign agencies, conducting operations that will span multiple countries and a wide range of jurisdictions. Because of the international nature of art crimes, international cooperation and openness is absolutely essential.

U.S. Immigration and Customs Enforcement (ICE) is another agency within the United States that handles different forms of art crimes, focusing on regulations and laws at the federal level. The bureau focuses on the laws that govern border control, customs, trade, and immigration, to safeguard and protect under the auspices of homeland security. Among their duties, the agency handles over four hundred federal statutes and will work alongside police departments while conducting their own investigations under their jurisdiction. The agents working for ICE will encounter a wide array of issues ranging from human traffick-

ing, drug trafficking, illegal immigration, smuggling, and arms trade, to name a few. [14]

ICE was created in March of 2003 as a result of the Homeland Security Act, which set about the creation of the largest government reorganization since the creation of the Department of Defense. Part of this reorganization was the creation of ICE, which gained a great deal of both civil and criminal authorities after the horrific acts of 9/11. Since that time, ICE has increased its authority becoming one of the highly regarded agencies of the federal government. [15]

In 2007, ICE took significant strides to join the rest of the international community in the prevention of crimes involving art and antiquities, specifically in the training of Homeland Security Investigations (HSI) personnel on the intricacies of cultural property, art, and antiquities investigations. Because of the major role illegal importation takes in this field, HSI takes jurisdiction when it comes to the enforcement of federal customs. Within their field of authority, HSI has the right to seize and examine any cultural or artistic artifacts and items that are entering the country illegally; this holds, for obvious reasons, especially true if the items are known to be stolen. [16]

The agents who participate in these training situations draw extensively from the modern trends of cultural property crimes. This extends to the point of being trained on the methods of authentication, safe handling and storage, and photographing works of art. Much of this training is offered in partnership with the Smithsonian Institution's Museum Conservation Institute. Not only does this better educate law enforcement, it also increases positive relations with interactions of foreign governments. By focusing on further enforcement and monitoring of international borders and customs, where much of this crime enters and exits this country, it raises the chances of catching many of these crimes before they can enter the marketplace and disappear into anonymity.

While the United States is still new to the field of art and cultural crimes, it has taken impressive strides to become a part of the solution for enforcement. The FBI focuses on the crimes that are committed within the borders of the United States, and ICE focuses on the primary areas where the United States is involved, through the enforcement of imports and exports. The United States is the primary market for both legal and illicit art and antiquities; much of the transport of

these items is decreased through strict customs enforcement agents with a working knowledge of communication with foreign governments.

Outside the United States, it is clear that serious effort is being taken by both governments and researchers. In this chapter we focused mainly on the agencies and entities that address the issue from a law enforcement perspective; however, there is even more being done from the point of view of research and education. As far as law enforcement is concerned, cultural crime is most heavily gauged in Europe and countries within the United Nations. Currently one of the major concerns is the prolific destruction and loss of cultural art and artifacts within the Middle East, where the conflict has been raging for so long that the ability to focus on the protection is limited within governmental agencies. Because of this limitation, civilians have taken the task upon themselves and are now involved in the ultimate goal of preventing the loss of these irreplaceable artifacts.

12

GROWTH OF ART CRIME AND
ART CRIME PREVENTION

Concluding this book, it is important to understand why art crime damages our society and why our culture is a valuable place to begin addressing this issue. Looking at the historical incidents that represent this crime is important, particularly in view of recent events, and realizing these are not meant strictly for the history books but to awaken us to the present situation around the world. Taking the time to examine the various law enforcement entities, as well as those who directly assist them, opens the way to question how officers, who are not specialized in the field, can help play a role in defining the path to solve many art crime problems. The final question remains: is this an issue that is subsiding, or is it a problem that is becoming increasingly prevalent?

While reviewing the current severity of art crimes, it is important to examine the groups who are dedicated to this area of research. Nongovernmental groups are becoming more and more common in this area of study. There are dedicated researchers and scholars combating the art crime–related issues by forestalling any debate through the effort of compiling information. These self-described think tanks take it upon themselves to make a career of maintaining open communication with one another, while assisting law enforcement and governments as needed.

Through the research and study of art crime, we have found something to be abundantly evident at every turn. Those who dedicate themselves to the study of art and cultural crimes do so to actually find

solutions. The field is small and not as well known or popular as other areas in the study of art. Those who research and study art crime are far more receptive to theories and studies applicable to this area. This behavior is based on the desire to find a solution and raise awareness on the matter. These think tanks are not created to make a profit and by definition are not-for-profit organizations. To properly combat any issue, researchers must sift through reams of documents and files to reveal accurate information that the public and law enforcement needs to view. The work done by scholars and researchers is often considered thankless when the evidence they unearth is ignored.

As discussed, it is extremely difficult to understand the exact cost of art and cultural crimes on a worldwide scale. While this holds true for almost any type of crime, the statistics related to art crimes are rarely a black-and-white matter. Many art crimes go unreported, underreported, or even undiscovered. As previously mentioned, if the thieves attempt to ransom a work back to the owner, there is a very good chance that the crime will go by without notice and will not be added into the official crime statistics databases around the world.

Having a specific field for classification of art and cultural crimes would go a long way toward keeping track of art crime statistics, but there also has to be a greater effort placed on reporting any and all crimes in this area. For those working in museums or galleries, the primary concern is the safe recovery of the artwork. Many people do not fully grasp the impact and benefit of accurate and diligent reporting. While the initial reports themselves may not immediately solve the case, the ability of researchers and law enforcement to accurately understand the severity of the issue would greatly benefit those in administration who delegate funding and design policy based on the need and importance of crimes.

Authors and researchers in the field believe that the frequency and severity of art related crimes has increased over the last century. While it is believable based on the increasing number of instances of art crimes, as well as the growing price tag associated with it, it is very difficult to verify this theory. There are a number of different factors that play into the subject, and each one needs to be taken into account if we are to fully understand the issue. Some of the greatest factors contributing to the theory of increased art crime are the Internet, mass media, and the ease with which information is passed and displayed.

Within recent years the ability to communicate instantly across the world has increased dramatically; as such, the media is able to discuss instances of crimes as soon as they are committed. When searching for these crimes, any individual can find that information almost instantly, rather than being forced to sift through police records and local newspapers.

Another factor is the classification methods of art and cultural crimes. Traditionally these crimes simply were not considered an issue. As a matter of fact, it was fairly commonplace, so no one bothered to report it as a crime. After World Wars I and II, these crimes were viewed more harshly due to the massive loss of cultural artifacts and artwork within Europe. As a result, further policies were placed on the trade and acquisition of these materials, ensuring that museums and private collectors were not encouraging the acts of looting or the funding of criminals in possession of stolen artwork.

Those studying art and antiquities crimes have raised serious concerns about modern museums. It has been stated that the majority of modern museums' collections put together since World War II are works with illicit and questionable provenance histories. This is a serious issue considering how many more museums are opening and how many collectors are ignoring the telltale signs of artwork with vague histories. The ways the collectors and museums can justify purchasing these works comes down to money. In order to generate a better reputation, or to draw in more crowds, museums and smaller galleries need "centerpieces" to build a display around. By having a single work to focus on, the gallery creates a theme and focus.

In order to generate a greater sense of theme, or to create a more prestigious display, the collector will seek out rare and sought-after works of art. In order to obtain these, the buyer will be more willing to overlook a questionable history. The seller will create or use vague histories in order to create an illusion of a legal work of art, obtained through honest and trustworthy means. These histories will say they were found in the countryside of a small town or that it was discovered in someone's attic. Sometimes the history will state a province that will describe an overly generalized location. Vague descriptions give the illusion of a legitimate history; without being overly specific, it is very difficult for anyone investigating them to actually track down an origin. As such, collectors are willing to overlook this type of unverifiable histo-

ry in the hopes that they will not be questioned too deeply on the subject at a later date.

The majority of those in the field have very little to no practical law enforcement experience; this is a serious problem. While the scholars can conduct the in-depth research and understand the cultural and historical impacts, it is very difficult for them to relate to street-level law enforcement personnel, who have seen the darker aspects of criminal investigations. Police do not view crime from a subjective viewpoint. This issue is not one strictly within the field of art and cultural crimes but is an overall discrepancy between the civilian mind-set and law enforcement mind-set. Seeing the darker side of any community on a daily basis warps the mind; it will change the way the officer or agent sees the world. As with all things, it is important to have a variety of perspectives, and while law enforcement may have difficulty agreeing with the scholarly approach, there are many different educational organizations and research groups pushing for a progression toward a greater awareness of art and cultural crimes.

The Association for Research into Crimes against Art (ARCA) is one of the foremost research organizations in the world on the subject of crimes involving art and culture. The group is devoted to advancing research and education in the fields of art crimes and cultural heritage protection. A great deal of the outreach in the world today involves providing education and publications to those interested. The group is the only source for a post-graduate certificate program in art crime prevention, which is offered during the summer months at the research group's location. In order to fully access the various aspects of the criminal field, ARCA uses a broad range of scholars from within their organization as well as partnerships and contributors. These scholars come from fields in law, criminal justice, security, museum studies, art history, archaeology, and cultural resource management studies.[1]

While ARCA is based in Amelia, Umbria, in Italy, the group's contributors and staff are scattered throughout the world. Just looking at the information online, a viewer can see that the group has staff located in Italy, England, Slovenia, the Netherlands, New Zealand, and the United States. Each of the staff members come from prestigious and well-rounded educational backgrounds—some from museum work, others from law enforcement, and a great many from fields related to

art and cultural crimes. One of the top contributors is the founder of the organization, Noah Charney, who is both an author and a scholar.

Another research organization is Trafficking Culture, an international group that focuses on producing evidence-based research on the modern trade of illegal artifacts. The group provides introductory information to the field. An encyclopedia-style format is used to organize the information for anyone who may not be familiar with the material. For those who have a bit more interest in the subject matter, the group also provides case studies and research from specialists. Not only does the group provide methodical research on antiquities trades, it also provides information on criminological and social theories that could help explain different aspects of culture crimes in general.[2]

Trafficking Culture is based out of Glasgow, Scotland, and maintains connections with the University of Glasgow, the European Research Council, and the Scottish Centre for Crime and Justice Research. While the researchers and scholars who work for the organization are all employed or associated with the University of Glasgow, the group does have considerable connections all over the world. These connections include Yale University, Virginia Commonwealth University, Simon Fraser University, ARCA, and numerous others. All of these individuals, including numerous other authors, contribute information that this group compiles in order to better understand the international trade in illicit cultural objects.

One of the few research groups in the United States is the Art Fraud Insights group, based out of Washington D.C. This is an excellent example of the progress the United States has made in representing the field of art and cultural crimes. The group provides preventative initiatives, exhibition assistance, specialized investigations, and publications. This is offered to assist in the prevention of some of the most important aspects of art and cultural crimes. The group focuses on ensuring the authenticity of the work on display, as well as working closely with scientists, forensic specialists, and art historians to provide the absolute best methods of ensuring that work is authentic and legal.[3]

Art Fraud Insights centers on the educational aspects in the field of art and cultural crimes by providing scholarships for those researching and studying in the field. The group is also interested in the protection of cultural heritage and philanthropic efforts in the area. Art Fraud Insights was founded by Colette Loll, who was a CEO of a marketing

software company for approximately fifteen years. She left to study in the area of decorative arts, eventually working her way into the field of art and cultural crimes. Since then Loll has been invited to speak at various universities, museums, and forensic institutes in the United States and Europe. She also trains federal agents in the Homeland Security Cultural Protection Program.

While not a research group in and of itself, there is an online blog called Illicit Cultural Property. This blog was started in 2006 by Derek Fincham when he was conducting his PhD research in cultural heritage law at the University of Aberdeen. The blog is a way of conveying information and passing along articles, publications, and news on the subject of art thefts, looting, and the legal framework on issues related to cultural crimes. Thanks to the informal nature of the blog, Dr. Fincham is able to convey his own ideas and opinions, along with keeping an open dialogue with those who read his work and follow his website. Dr. Fincham is currently an associate professor of law at South Texas College of Law; he teaches writing, research, and appellate litigation.[4]

By keeping an online blog, the information that is provided is accessible to all readers. The information is free, and the personal touch that an author can add makes it considerably more relatable. The authors are not limited to the scholarly field, including the requirement of degrees, connections, and the extra paperwork and processes involved in peer reviewed publications. The authors are not forced to maintain an unbiased perspective or confine themselves to backing up all the information they provide; they are capable of providing their own opinions, offering a more "human" voice on the subject matter. This of course, is not as official as a peer-reviewed source, and unless the information is cited, does not provide the reader with legitimate information. It does however, open up the field to those with less education and with a less scholarly approach, making it comfortable for any viewer.

The prevention methods for art and cultural crimes, and the push for educational advancement within the field, represent a growth of information on the subject. Whether or not the actual frequency of art crimes is increasing is irrelevant. The fact is we are more aware of the scale of crimes being committed within the field than ever before. This means that there are either more crimes being committed or simply that we have access to more information. The works of multiple authors, organizations, researchers, and governments viewing this type of

crime as the third-highest annual criminal grossing income in the world lead us to believe it must be taken very seriously. The fact that multiple sources identify this crime as a major problem means there is cause for alarm.

While law enforcement is on the front line of investigating art crime, education and research are absolutely necessary to successfully handle this problem. Many believe that law enforcement and the art world are polar opposites, yet this field of study is the perfect example of how the two can be combined. The combination of law enforcement and the art world is on a global scale combining all countries and cultures. Art crime is a direct threat to history and the ideal of who we are as individuals and citizens of our countries.

To ensure accurate information and official statistics on art and cultural crimes, the United States needs to record this information accurately in the UCR. It is mandatory that we are provided with the data to understand the frequency and trends of art crimes on a national as well as international level. The policies in place through the United Nations, as well as the efforts of the countries that have contributed and placed their time, effort, and finances to combat the issue, need to continue to lead this progression. Many of these very same countries have taken incredible strides in international cooperation, not only in terms of law enforcement but also in education and research. The organizations that strive to fully understand the matter do not hesitate to extend their efforts across borders; they encourage it. Something that is rarely seen and absolutely needed.

The combination of law enforcement and the art world is imperative because it represents life itself. Art works and artifacts represent history and culture, and each item is irreplaceable, much like a human life. This spurs a debate that is widely considered throughout art and cultural heritage. Which has greater value—art and artifacts or a human life? On one hand you have human life that is precious as well as irreplaceable; while on the other hand, the representation of culture and history is something that has lasted thousands of years and if destroyed is lost forever. Those in law enforcement who have worked in the study of art crimes at some point mention putting their lives in danger to keep these works safe and to ensure their recovery. Even the Monuments Men in World War II put their lives on the line, entering into countless situations that put them directly in harm's way. Today, this same practice

can be seen in Syria, where groups of archaeologists and art historians are entering active war zones, moving ahead of terrorist groups to recover art and artifacts that the regimes cannot recover themselves. These individuals are putting their lives in danger, believing the recovery of historical and cultural identities is worth risking their lives.

The arguments for human life can be made just as convincingly. Human life is unique and the loss of life is an event that cannot be overstated. The abuse and neglect of human life is one of the primary reasons why law enforcement exists. Agencies make it one of their primary goals to search out and prosecute the most violent offenders. For those abroad, foreign aid is sent to improve the livelihoods of those less fortunate. Without the appreciation for human life, history and cultural identity would have absolutely no meaning. Human life is required in the creation of history as well as for the appreciation of our cultural identity. Dr. Amr Al-Azm stated that debating on which is more important cannot be viewed as a simple choice of one over the other—*both* need to be held in high esteem. Without one, the other would lose its significance. Human life without its culture and history would be flat and to many, meaningless; while culture and history without human life would go unappreciated and forgotten.

NOTES

2. WHY DOES ART MATTER?

1. Jeff Eastin, producer, "Stealing Home," *White Collar*, USA Network (episode no. 3-15, first broadcast February 21, 2012).
2. National Endowment for the Arts, "A Decade of Arts Engagement: Findings from the Survey of Public Participation in the Arts, 2002–2012," https://www.arts.gov/sites/default/files/2012-sppa-jan2015-rev.pdf.
3. National Endowment for the Arts. "A Decade of Arts Engagement."
4. National Endowment for the Arts. "A Decade of Arts Engagement."
5. Timothy Ambrose and Crispin Paine, *Museum Basics*, 2nd ed. (New York: Routledge, 2006).
6. Ambrose and Paine, *Museum Basics*.
7. American Art Therapy Association, http://arttherapy.org/.
8. "About AATA," American Art Therapy Association, http://arttherapy.org/aata-aboutus/.
9. Helen Gardner and Fred S. Kleiner, *Gardner's Art through the Ages: The Western Perspective* (Boston, MA: Wadsworth Cengage Learning, 2010).

3. WHAT IS ART CRIME?

1. Noah Charney, "Art Crime in North America," *Association for Research into Crimes against Art* (2012): 79–83.
2. Robert K. Wittman, "Cold Case," in *Priceless: How I Went Undercover to Rescue the World's Stolen Treasures* (New York: Crown, 2010), 249–55.

3. Stuart George, review of Anthony M. Amore and Tom Mashberg's *Stealing Rembrandts: The Untold Stories of Notorious Art Heists* (New York: Palgrave Macmillan, 2011), in the *Journal of Art Crime* 7 (2012): 84–85.

4. "Sybille of Cleves," Association for Research into Crimes against Art, accessed September 13, 2016, http://www.artcrimeresearch.org/sybille-of-cleves/.

5. Juliet Ceresole, "From Artifice to Artefact," Victoria and Albert Museum (blog), February 10, 2016, http://www.vam.ac.uk/blog/national-art-library/from-artifice-to-artefact.

6. Noah Charney, "The Magician in the Red Turban," in *Stealing the Mystic Lamb: The True Story of the World's Most Stolen Masterpiece* (New York: Public Affairs, 2012), 61–63.

7. "United States of America v. Glafira Rosales," U.S. Department of Justice, https://www.justice.gov/archive/usao/nys/pressreleases/July13/Rosales-GlafiraIndictmentPR/U.S. v. Glafira Rosales Indictment.pdf.

8. B. A. Bowman, "Transnational Crimes against Culture: Looting at Archaeological Sites and the 'Grey' Market in Antiquities," *Journal of Contemporary Criminal Justice* 24.3 (2008): 225–42.

9. David Gill, "Context Matters: The Unresolved Case of the Minneapolis Krater," *Association for Research into Crimes against Art* (2011): 57–61.

10. Noah Charney, "The Canon Hides the Lamb," in *Stealing the Mystic Lamb: The True Story of the World's Most Stolen Masterpiece* (New York: Public Affairs, 2012), 117–18.

11. Charney, "The Canon Hides the Lamb."

12. Charney, "Art Crime in North America."

13. Ludo Block, "European Police Cooperation on Art Crime: A Comparative Overview," *Journal of Art Crime* 5 (2011): 13–25.

4. HISTORY OF ART AND ART-RELATED CRIMES

1. Paul S. Ghiringhelli, "Army Archaeologist Studying in Rome Increases Her Influence," U.S. Army, February 24, 2011, https://www.army.mil/article/52361/Army_archaeologist_studying_in_Rome_increases_her_influence.

2. Noah Charney, *Stealing the Mystic Lamb: The True Story of the World's Most Stolen Masterpiece* (New York: Public Affairs, 2012).

3. "Republic of Austria v. Altman 541 U.S. 677 (2004)," Justia Law, October 2003, https://supreme.justia.com/cases/federal/us/541/677/.

4. Charney, *Stealing the Mystic Lamb.*

5. Robert M. Edsel and Bret Witter, *The Monuments Men: Allied Heroes, Nazi Thieves, and the Greatest Treasure Hunt in History* (New York: Center Street, 1976).

6. John E. Conklin, *Art Crime* (Westport, CT: Praeger, 1994).

7. Andrew L. Slayman, "Geneva Seizure," *Archaeology*, Online Features, May 3, 1998, updated September 14, 1998, http://archive.archaeology.org/online/features/geneva/.

8. Charlotte Alter, "The 5 Best Museum Heists in History," *Time*, May 18, 2014, http://time.com/103212/the-5-best-museum-heists-in-history/.

9. "Convention on the Means of Prohibiting and Preventing the Illicit Import, Export and Transfer of Ownership of Cultural Property 1970," November 14, 1970, United Nations Educational Scientific and Cultural Organization, http://portal.unesco.org/en/ev.php-URL_ID=13039&URL_DO=DO_TOPIC&URL_SECTION=201.html.

10. "The Fight against the Illicit Trafficking of Cultural Objects: The 1970 Convention: Past and Future," Information Kit; March 15 and 16, 2011, United Nations, http://unesdoc.unesco.org/images/0019/001916/191606E.pdf.

11. Alter, "The 5 Best Museum Heists in History."

12. Noah Charney, *The Art of Forgery: The Minds, Motives and Methods of Master Forgers* (New York: Phaidon, 2015).

13. "Theft," Isabella Stewart Gardner Museum, Resources, http://www.gardnermuseum.org/resources/theft.

14. "FBI Top Ten Art Crimes," FBI, What We Investigate, https://www.fbi.gov/investigate/violent-crime/art-theft/fbi-top-ten-art-crimes.

15. "Swedish Art Heist," Crime Museum, http://www.crimemuseum.org/crime-library/swedish-art-heist/.

16. "FBI Top Ten Art Crimes."

17. "Statement from the Archaeological Institute of America Concerning the Looting of Artifacts in Egypt," Archaeological Institute of America, February 1, 2011, https://www.archaeological.org/news/aianews/3934.

18. "The Fight against the Illicit Trafficking of Cultural Objects."

5. CULTURAL DIFFERENCES BETWEEN THE UNITED STATES AND EUROPE

1. Marvin Harris, *Theories of Culture in Postmodern Times* (Walnut Creek: AltaMira, 1999).

2. "Colonization," U.S. Department of State, United States Economy, http://countrystudies.us/united-states/economy-3a.htm.

3. Judith Pizarro, Roxane Cohen Silver, and JoAnne Prause, "Physical and Mental Health Costs of Traumatic War Experiences Among Civil War Veterans," February 1, 2006, *JAMA Psychiatry* 63(2): 193–200, http://archpsyc.jamanetwork.com/article.aspx?articleid=209288.

4. "The Army Values," U.S. Army Homepage, https://www.army.mil/values/.

5. "How The U.S. Economy Works," U.S. Department of State, http://usa.usembassy.de/etexts/oecon/chap2.htm.

6. Josh Johns, "Jefferson and the Politics of Architecture," Thomas Jefferson: The Architect of a Nation. The American Studies Group, University Virginia, 1996, http://xroads.virginia.edu/~cap/jeff/jeffarch.html, pp. 1–3.

7. Virginia Department of Historic Resources, *Notes on Virginia* 51 (2007): http://dhr.virginia.gov/pdf_files/NOTES2007FINALPDF2.pdf.

8. Johns, "Jefferson and the Politics of Architecture."

9. Colin Marshall, "Pruitt-Igoe: The Troubled High-Rise That Came to Define Urban America—A History of Cities in 50 Buildings, Day 21," A History of Cities in 50 Buildings, *The Guardian*, April 22, 2015, https://www.theguardian.com/cities/2015/apr/22/pruitt-igoe-high-rise-urban-america-history-cities.

10. Klaus von Beyme, *On Political Culture, Cultural Policy, Art and Politics*, SpringerBriefs on Pioneers in Science and Practice, Volume 15, edited by Hans Günter Brauch (Cham: Springer, 2014): chapters 2, 19–33, and 7, pp. 101–116.

11. Aijaz Ahmad, *In Theory: Classes, Nations, Literatures* (New York: Verso, 1992).

12. Philadelphia Museum of Art website, http://www.philamuseum.org/collections/permanent/104384.html.

13. Faith Ringgold website, http://www.faithringgold.com/ringgold/default.htm.

14. "Chinese-American Contribution to Transcontinental Railroad," Central Pacific Railroad Photographic History Museum, accessed November 2015, http://cprr.org/Museum/Chinese.html.

15. Stephen Hicks, "Why Art Became Ugly," The Atlas Society, September 1, 2004, http://atlassociety.org/students/students-blog/3671-why-art-became-ugly.

16. Metropolitan Museum of Art, "Arts of the Spanish Americas, 1550–1850," 2000–2016 http://www.metmuseum.org/toah/hd/spam/hd_spam.htm.

17. Maria T. Avila, "Conceptions and Representations of Latinos and Mainstream Museums in the United States," Smithsonian Center for Latino In-

itiates, 2003, http://latino.si.edu/researchandmuseums/presentations/avi-la_papers.html.

18. National Museum of the American Indian, http://nmai.si.edu/explore/collections/history/.

6. LOOTING OF ART AND ARCHAEOLOGICAL SITES

1. Interview with author Noah Charney, 2016.

2. Ginger Pinholster, "AAAS Satellite Image Analysis: Five of Six Syrian World Heritage Sites 'Exhibit Significant Damage,'" American Association for the Advancement of Science, September 18, 2014, https://www.aaas.org/news/aaas-satellite-image-analysis-five-six-syrian-world-heritage-sites-exhibit-significant-damage.

3. Brian Schatz, "Meet the 'Monuments Men' Risking Everything to Save Syria's Ancient Treasures from ISIS," Mother Jones, March 6, 2015, http://www.motherjones.com/politics/2015/02/how-isis-cashes-illegal-antiquities-trade.

4. Josh Elliott, "How ISIS Became the Richest Terrorist Group in the World," CTV News, June 17, 2014, http://www.ctvnews.ca/world/how-isis-became-the-richest-terrorist-group-in-the-world-1.1872634.

5. Jay Akbar, "'Indisputable Evidence ISIS Is a Criminal Gang': US Returns Hundreds of Priceless Iraqi Artefacts Looted by Islamists after Raid on Islamic State's Top Financier," MailOnline, July 15, 2016, http://www.dailymail.co.uk/news/article-3162731/Indisputable-evidence-ISIS-criminal-gang-returns-hundreds-priceless-Iraqi-artefacts-looted-Islamists-raid-Islamic-State-s-financier.html.

6. Amr Al-Azm, doctor of Middle East History and Anthropology department of Shawnee University, personal interview, May 2016.

7. "ISIL and Antiquities Trafficking: FBI Warns Dealers, Collectors about Terrorist Loot," FBI website, August 26, 2015, https://www.fbi.gov/news/stories/2015/august/isil-and-antiquities-trafficking/isil-and-antiquities-trafficking.

8. France Desmarais, *Countering Illicit Traffic in Cultural Goods: The Global Challenge of Protecting the World's Heritage* (Paris: ICOM, 2015).

9. Neil Brodie, "The Investment Potential of Antiquities" (working paper, Stanford University. Archaeology Center, Version 1, August 2009).

10. Interview with author Noah Charney, 2016.

11. Museums Association Ethics Committee, "Acquisition: Guidance on the Ethics and Practicalities of Acquisition," Ethical Guidelines (no. 1, 2nd ed.,

2004), para. 2.6 (code 8.1): https://www.museumsassociation.org/ethics/code-of-ethics.

12. Museums Association Ethics Committee, "Acquisition: Guidance on the Ethics and Practicalities of Acquisition," para. 4.7.

13. Museums Association Ethics Committee, "Acquisition: Guidance on the Ethics and Practicalities of Acquisition," para. 2.7 (code 5.7) and para. 2.8 (code 5.10–5.11).

14. Eric Kelsey, "Germany's Pergamon Museum Returns Ancient Sphinx of Hattusa to Its Home in Turkey," Artdaily.org, August 10, 2011, http://artdaily.com/news/49494/Germany-s-Pergamon-Museum-Returns-Ancient-Sphinx-of-Hattusa-to-Its-Home-in-Turkey#.V9wsYJgrKUk.

15. "Turkey Bans Foreign Archaeologists to Excavate, as Long as the West Does Not Return the Disputed Artifacts," ARTinvestment.ru, January 28, 2013, http://artinvestment.ru/en/news/artnews/20130128_turkey_bans_archeological_digs.html.

7. ECONOMIC IMPACT OF ART AND ART-RELATED CRIMES

1. U.S. Immigration and Customs Enforcement, "Cultural Property, Art and Antiquities Investigations," April 2016, https://www.ice.gov/cultural-art-investigations

2. International Monetary Fund, "The IMF and the Fight against Money Laundering and the Financing of Terrorism," Factsheet, March 21, 2016, http://www.imf.org/external/np/exr/facts/aml.htm.

3. U.S. Immigration and Customs Enforcement, "Trade Transparency Unit," https://www.ice.gov/trade-transparency.

4. U.S. Immigration and Customs Enforcement, "ICE HSI Partners with Ball State University and the David Owsley Museum of Art to Recover a Hidden Idol Stolen from India," Cultural Property, Art and Antiquities Investigations, November 17, 2015, https://www.ice.gov/news/releases/ice-hsi-partners-ball-state-university-and-david-owsley-museum-art-recover-hidden-idol.

5. Eileen Kinselia, "'Operation Hidden Idol' Seizes Yet Another Suspect Sculpture from NYC Gallery," Artnet News, March 17, 2016, https://news.artnet.com/market/feds-seize-another-ancient-statue-451703.

6. Eileen Kinselia and Christian Viveros-Faune, "Newly-Revealed Documents Show Sotheby's Contacted Helly Nahmad about Modigliani Claim," Artnet News, May 16, 2016, https://news.artnet.com/market/documents-show-sothebys-contacted-helly-nahmad-about-modigliani-claim-495047.

7. U.S. Immigration and Customs, "ICE Returns Dinosaur Skeletons, Eggs to Mongolia," Cultural Property, Art and Antiquities Investigations, April 5, 2016, https://www.ice.gov/news/releases/ice-returns-dinosaur-skeletons-eggs-mongolia.

8. International Monetary Fund, "IMF Survey: Fighting Corruption Critical for Growth and Macroeconomic Stability—IMF Paper," May 11, 2016, http://www.imf.org/en/news/articles/2015/09/28/04/53/sores051116a.

9. International Monetary Fund, "IMF Survey."

8. MUSEUMS

1. Personal interview with executive director Hayes Scriven of the Northfield Historical Society (Northfield, Minnesota), January 6, 2016.

2. Hayes Scriven, personal interview.

3. "Theft," Isabella Stewart Gardner Museum," http://www.gardnermuseum.org/resources/theft.

4. Lynda Albertson, "Ankara, Turkey: Anonymous Caller Breaks Open Case in Art Theft Investigation at the State Art and Sculpture Museum," ARCA blog, November 12, 2014, http://art-crime.blogspot.com/2014/11/anonymous-caller-breaks-open-case-in.html.

5. Sarah Cascone, "Master Forger Librarian Swaps 143 Artworks with His Own," Artnet News, July 21, 2015, https://news.artnet.com/exhibitions/chinese-librarian-art-forger-318533.

6. "Statement by the Press Secretary on the Attack at Tunisia's National Bardo Museum," The White House, Office of the Press Secretary, March 18, 2015, https://www.whitehouse.gov/the-press-office/2015/03/18/statement-press-secretary-attack-tunisia-s-national-bardo-museum.

9. POLICE DEMANDS, SCRUTINY, EDUCATION, AND THE FUTURE

1. James B. Comey, "Race and Law Enforcement: FBI Director Furthers the Discussion," FBI News (blog), October 23, 2015, https://www.fbi.gov/news/stories/race-and-law-enforcement-fbi-director-furthers-the-discussion.

2. "FBI Directors Rely on UCR Data," CJIS Link, June 13, 2016, https://www.fbi.gov/services/cjis/cjis-link/fbi-directors-rely-on-ucr-data.

3. "Report to the Deputy Attorney General on the Events at Waco, Texas, February 28 to April 19, 1993," October 8, 1993 [Redacted Version], https://

en.wikisource.org/wiki/Re-port_to_the_Deputy_Attorney_General_on_the_Events_at_Waco,_Texas.

4. Force Science Institute Ltd., July 1, 2016, http://www.forcescience.org/.

5. Charles Remsberg, "Telling the Truth about Police Shootings," *The Police Marksman* 29, no. 2 (November/December 2004): http://www.forcescience.org/articles/tellingthetruth.pdf.

6. Ralph Heibutzki, "Minimum Qualifications for Police Chief Employment," Chron, http://work.chron.com/minimum-qualifications-police-chief-employment-15564.html.

7. Matthew D. Bostrom, "The Influence of Higher Education on Police Officer Work Habits," *The Police Chief* 72, no. 10 (October 2005): http://www.policechiefmagazine.org/magazine/index.cfm?fuseaction=display_arch&article_id=722&issue_id=102005.

8. U.S. Immigration and Customs Enforcement, "Investigating Illegal Movement of People and Goods," Cornerstone, June 10, 2016, https://www.ice.gov/cornerstone.

10. WAYS IN WHICH LAW ENFORCEMENT CAN FOCUS ON ART CRIMES

1. Department of Homeland Security, "ICE Returns Dinosaur Skeletons, Eggs to Mongolia," U.S. Immigration and Customs Enforcement, April 5, 2016, https://www.ice.gov/news/releases/ice-returns-dinosaur-skeletons-eggs-mongolia.

2. Russell Contreras, "Officer Stumbles upon Valuable Works by American Indian Artist Alfred Momaday in Old Meth Lab," *U.S. News and World Report*, February 6, 2015, http://www.usnews.com/news/offbeat/articles/2015/02/06/american-indian-artists-works-discovered-in-old-meth-lab.

3. Colleen, Clarke, "Studying Police Education Abroad in the Wake of Transnational Organized Crime," *National Social Science Journal* 46, no. 1 (2016): 25–32.

4. Camila Domonoske, "Native Americans Protest a Planned Auction of Sacred Objects in France," NPR, May 25, 2016, http://www.npr.org/sections/thetwo-way/2016/05/25/479455188/native-americans-protest-planned-auction-of-sacred-objects-in-france.

5. Judith Benderson, "The Archaeological Resources Protection Act and the Native American Graves Protection and Repatriation Act," Native American Artifacts, United States Department of Justice, July 8, 2015, https://www.justice.gov/usao/priority-areas/indian-country/native-american-artifacts.

6. Telephone interview with Dr. Amr Al-Azm Amr, an associate professor of Middle East history and anthropology at Shawnee State University in Ohio, May 2016.

11. SECURITY AND POLICING IN ART CRIME THROUGHOUT THE WORLD

1. "Overview," United Nations, UN News Center, http://www.un.org/en/sections/about-un/overview/index.html.
2. "Introducing UNESCO," UNESCO, http://en.unesco.org/about-us/introducing-unesco.
3. "Introducing UNESCO."
4. United Nations Office on Drugs and Crime, https://www.unodc.org/.
5. "About," Art Recovery International, http://artrecovery.com/About.
6. "Overview," About INTERPOL, INTERPOL, http://www.interpol.int/About-INTERPOL/Overview.
7. "Works of Art," Crime Areas, INTERPOL, http://www.interpol.int/Crime-areas/Works-of-art/Works-of-art.
8. "The Ancient Corps of the Royal Carabinieri," Ministero Della Difesa, Carabinieri, http://www.carabinieri.it/multilingua/en/the-ancient-corps-of-the-royal-carabinieri-_898e145c18314ef1bcd033c6dde57744.
9. "The Carabinieri TPC," Ministero Della Difesa, Carabinieri, http://www.carabinieri.it/multilingua/en/the-carabinieri-tpc.
10. "Art and Antiques," Metropolitan Police, http://content.met.police.uk/Site/artandantiques.
11. "About," FBI, https://www.fbi.gov/about.
12. "Art Theft," FBI, https://www.fbi.gov/investigate/violent-crime/major-cases/art-theft.
13. "Art Crime Team," FBI, https://www.fbi.gov/investigate/violent-crime/major-cases/art-theft.
14. "Who We Are," ICE, U.S. Immigration and Customs Enforcement, https://www.ice.gov/about.
15. "History," ICE, U.S. Immigration and Customs Enforcement, https://www.ice.gov/history.
16. "Cultural Property, Art and Antiquities Investigations," ICE, U.S. Immigration and Customs Enforcement, https://www.ice.gov/cultural-art-investigations.

12. GROWTH OF ART CRIME AND
ART CRIME PREVENTION

1. "Our Work," ARCA, Association for Research into Crimes against Art, http://www.artcrimeresearch.org/our-work/.
2. Trafficking Culture, http://traffickingculture.org/.
3. Art Fraud Insights, http://www.artfraudinsights.com/.
4. Illicit Cultural Property, http://illicitculturalproperty.com/.

BIBLIOGRAPHY

Ahmad, Aijaz. *In Theory: Classes, Nations, Literatures*. New York: Verso, 1992.

Akbar, Jay. "'Indisputable Evidence ISIS Is a Criminal Gang': US Returns Hundreds of Priceless Iraqi Artefacts Looted by Islamists after Raid on Islamic State's Top Financier." MailOnline, July 15, 2016. http://www.dailymail.co.uk/news/article-3162731/Indisputable-evidence-ISIS-criminal-gang-returns-hundreds-priceless-Iraqi-artefacts-looted-Islamists-raid-Islamic-State-s-financier.html.

Albertson, Lynda. "Ankara, Turkey: Anonymous Caller Breaks Open Case in Art Theft Investigation at the State Art and Sculpture Museum." ARCA blog, November 12, 2014. http://art-crime.blogspot.com/2014/11/anonymous-caller-breaks-open-case-in.html.

Alter, Charlotte. "The 5 Best Museum Heists in History," *Time*, May 18, 2014, http://time.com/103212/the-5-best-museum-heists-in-history/.

Ambrose, Timothy, and Crispin Paine. *Museum Basics*. 2nd ed. New York: Routledge, 2006.

American Art Therapy Association. "About AATA." http://arttherapy.org/aata-aboutus/.

Archaeological Institute of America. "Statement from the Archaeological Institute of America Concerning the Looting of Artifacts in Egypt." February 1, 2011. https://www.archaeological.org/news/aianews/3934.

Art Investment.RU. "Turkey Bans Foreign Archaeologists to Excavate, as Long as the West Does Not Return the Disputed Artifacts." January 28, 2013. http://artinvestment.ru/en/news/artnews/20130128_turkey_bans_archeological_digs.html.

Art Recovery International. ARG. "About. http://artrecovery.com/About.

Association for Research into Crimes against Art (ARCA). "Our Work." http://www.artcrimeresearch.org/our-work/.

Association for Research into Crimes against Art. "Sybille of Cleves." http://www.artcrimeresearch.org/sybille-of-cleves.

Avila, Maria T. "Conceptions and Representations of Latinos and Mainstream Museums in the United States." Smithsonian Center for Latino Initiates. 2003. http://latino.si.edu/researchandmuseums/presentations/avila_papers.html.

Benderson, Judith. "The Archaeological Resources Protection Act and the Native American Graves Protection and Repatriation Act." Native American Artifacts. United States Department of Justice. July 8, 2015. https://www.justice.gov/usao/priority-areas/indian-country/native-american-artifacts.

Block, Ludo. "European Police Cooperation on Art Crime: A Comparative Overview." *Journal of Art Crime* 5 (2011): 13–25.

Bostrom, Matthew D. "The Influence of Higher Education on Police Officer Work Habits." *The Police Chief* 72, no. 10 (October 2005): http://www.policechiefmagazine.org/magazine/index.cfm?fuseaction=display_arch&article_id=722&issue_id=102005.

Bowman, B. A. "Transnational Crimes against Culture: Looting at Archaeological Sites and the 'Grey' Market in Antiquities." *Journal of Contemporary Criminal Justice* 24.3 (2008): 225–42.

Brodie, Neil. "The Investment Potential of Antiquities." Working paper. Stanford University. Archaeology Center. Version 1. August 2009.

Cascone, Sarah. "Master Forger Librarian Swaps 143 Artworks with His Own." Artnet News, July 21, 2015. https://news.artnet.com/exhibitions/chinese-librarian-art-forger-318533.

Central Pacific Railroad Photographic History Museum. "Chinese-American Contribution to Transcontinental Railroad." Accessed November 2015, http://cprr.org/Museum/Chinese.html.

Ceresole, Juliet. "From Artifice to Artefact." Victoria and Albert Museum (blog), February 10, 2016. http://www.vam.ac.uk/blog/national-art-library/from-artifice-to-artefact.

Charney, Noah. "Art Crime in North America." *Association for Research into Crimes against Art* (2012): 79–83.

Charney, Noah. *The Art of Forgery: The Minds, Motives and Methods of Master Forgers.* New York: Phaidon, 2015.

Charney, Noah. "The Canon Hides the Lamb." In *Stealing the Mystic Lamb: The True Story of the World's Most Stolen Masterpiece*, 117–18. New York: Public Affairs, 2012.

Charney, Noah. "The Magician in the Red Turban." In *Stealing the Mystic Lamb: The True Story of the World's Most Stolen Masterpiece*, 61–63. New York: Public Affairs, 2012.

Charney, Noah. *Stealing the Mystic Lamb: The True Story of the World's Most Stolen Masterpiece.* New York: Public Affairs, 2012.

Charney, Noah, Paul Denton, and John Kleberg. " Protecting Cultural Heritage from Art Theft: International Challenge, Local Opportunity." FBI Law Enforcement Bulletin, March 2012. https://leb.fbi.gov/2012/march/protecting-cultural-heritage-from-art-theft-international-challenge-local-opportunity.

Clarke, Colleen. "Studying Police Education Abroad in the Wake of Transnational Organized Crime." *National Social Science Journal*, Volume 46, Number 1, 2016.

Conklin, John E. *Art Crime.* Westport, CT: Praeger, 1994.

Contreras, Russell. "Officer Stumbles upon Valuable Works by American Indian Artist Alfred Momaday in Old Meth Lab." *U.S. News and World Report*, February 6, 2015. http://www.usnews.com/news/offbeat/articles/2015/02/06/american-indian-artists-works-discovered-in-old-meth-lab.

Desmarai, France, editor. *Countering Illicit Traffic in Cultural Goods: The Global Challenge of Protecting the World's Heritage.* Paris: ICOM, 2015.

Domonoske, Camila. "Native Americans Protest a Planned Auction of Sacred Objects in France." NPR. May 25. 2016. http://www.npr.org/sections/thetwo-way/2016/05/25/479455188/native-americans-protest-planned-auction-of-sacred-objects-in-france.

Eastin, Jeff, prod. "Stealing Home." *White Collar.* USA Network. Episode no. 3-15, first broadcast February 21, 2012.

Edsel, Robert M., and Bret Witter. *The Monuments Men: Allied Heroes, Nazi Thieves, and the Greatest Treasure Hunt in History.* New York: Center Street, 1976.

Elliott, Josh. "How ISIS Became the Richest Terrorist Group in the World." CTV News. June 17, 2014. http://www.ctvnews.ca/world/how-isis-became-the-richest-terrorist-group-in-the-world-1.1872634 .

FBI. "About." https://www.fbi.gov/about.

FBI. "Art Crime Team." https://www.fbi.gov/investigate/violent-crime/major-cases/art-theft.

FBI. "Art Theft." https://www.fbi.gov/investigate/violent-crime/major-cases/art-theft.

FBI. "ISIL and Antiquities Trafficking: FBI Warns Dealers, Collectors About Terrorist Loot" Aug. 2015. Web https://www.fbi.gov/news/stories/2015/august/isil-and-antiquities-trafficking/isil-and-antiquities-trafficking.

FBI. "FBI Top Ten Art Crimes," FBI, What We Investigate, https://www.fbi.gov/investigate/violent-crime/art-theft/fbi-top-ten-art-crimes.

Gardner, Helen, and Fred S. Kleiner. *Gardner's Art through the Ages: The Western Perspective.* Boston, MA: Wadsworth Cengage Learning, 2010.

George, Stuart. Review of *Stealing Rembrandts: The Untold Stories of Notorious Art Heists* (New York: Palgrave Macmillan, 2011). In *Journal of Art Crime* 7 (2012): 84–85.

Ghiringhelli, Paul S. "Army Archaeologist Studying in Rome Increases Her Influence." U.S. Army, February 24, 2011. https://www.army.mil/article/52361/Army_archaeologist_studying_in_Rome_increases_her_influence.

Gill, David. "Context Matters: The Unresolved Case of the Minneapolis Krater." *Association for Research into Crimes against Art* (2011): 57–61.

Harris, Marvin. *Theories of Culture in Postmodern Times*. Walnut Creek: AltaMira, 1999.

Heibutzki, Ralph. "Minimum Qualifications for Police Chief Employment." Chron. http://work.chron.com/minimum-qualifications-police-chief-employment-15564.html.

Hicks, Stephen. "Why Art Became Ugly." The Atlas Society. September 1, 2004. http://atlassociety.org/students/students-blog/3671-why-art-became-ugly.

International Monetary Fund, "IMF Survey: Fighting Corruption Critical for Growth and Macroeconomic Stability—IMF Paper." May 11, 2016. http://www.imf.org/en/news/articles/2015/09/28/04/53/sores051116a.

International Monetary Fund "The IMF and the Fight against Money Laundering and the Financing of Terrorism." Factsheet. March 21, 2016. http://www.imf.org/external/np/exr/facts/aml.htm.

INTERPOL. "Overview." About INTERPOL. http://www.interpol.int/About-INTERPOL/Overview.

INTERPOL. "Works of Art." Crime Areas. http://www.interpol.int/Crime-areas/Works-of-art/Works-of-art.

Isabella Stewart Gardner Museum. "Theft." Resources. http://www.gardnermuseum.org/resources/theft.

Johns, Josh. "Jefferson and the Politics of Architecture." Thomas Jefferson: The Architect of a Nation. The American Studies Group, University Virginia, 1996, http://xroads.virginia.edu/~cap/jeff/jeffarch.html, pp. 1–3.

Kelsey, Eric. "Germany's Pergamon Museum Returns Ancient Sphinx of Hattusa to Its Home in Turkey." Artdaily.org. August 10, 2011. http://artdaily.com/news/49494/Germany-s-Pergamon-Museum-Returns-Ancient-Sphinx-of-Hattusa-to-Its-Home-in-Turkey#.V9wsYJgrKUk.

Kinselia, Elieen, and Christian Viveros-Faune. "Newly-Revealed Documents Show Sotheby's Contacted Helly Nahmad about Modigliani Claim." Artnetnews, May 16, 2016. https://news.artnet.com/market/documents-show-sothebys-contacted-helly-nahmad-about-modigliani-claim-495047.

Marshall, Colin. "Pruitt-Igoe: The Troubled High-Rise That Came to Define Urban America—A History of Cities in 50 Buildings, Day 21." A History of Cities in 50 Buildings. *The Guardian*, April 22, 2015. https://www.theguardian.com/cities/2015/apr/22/pruitt-igoe-high-rise-urban-america-history-cities.

Mashberg, Tom. "Law Enforcement Focuses on Asia Week in Inquiry of Antiquities Smuggling." *New York Times*, March 17, 2016. http://www.nytimes.com/2016/03/18/arts/design/law-enforcement-focuses-on-asia-week-in-inquiry-of-antiquities-smuggling.html?_r=0.

Metropolitan Museum of Art, "Arts of the Spanish Americas, 1550–1850," 2000–2016. http://www.metmuseum.org/toah/hd/spam/hd_spam.htm.

Metropolitan Police. "Art and Antiques." http://content.met.police.uk/Site/artandantiques.

Ministero Della Difesa, Carabinieri. "The Ancient Corps of the Royal Carabinieri." http://www.carabinieri.it/multilingua/en/the-ancient-corps-of-the-royal-carabinieri-_898e145c18314ef1bcd033c6dde57744.

Ministero Della Difesa, Carabinieri. "The Carabinieri TPC." http://www.carabinieri.it/multilingua/en/the-carabinieri-tpc.

Museums Association Ethics Committee. "Acquisition: Guidance on the Ethics and Practicalities of Acquisition." Ethical Guidelines, no. 1, 2nd ed., 2004, para. 2.6 (code 8.1): https://www.museumsassociation.org/download?id=11114.

National Endowment for the Arts. "A Decade of Arts Engagement: Findings from the Survey of Public Participation in the Arts, 2002–2012." https://www.arts.gov/sites/default/files/2012-sppa-jan2015-rev.pdf.

National Museum of the American Indian, http://nmai.si.edu/explore/collections/history/.

Philadelphia Museum of Art. Collections. http://www.philamuseum.org/collections/permanent/104384.html.

Pinholster, Ginger. "AAAS Satellite Image Analysis: Five of Six Syrian World Heritage Sites 'Exhibit Significant Damage.'" American Association for the Advancement of Science. September 18, 2014. https://www.aaas.org/news/aaas-satellite-image-analysis-five-six-syrian-world-heritage-sites-exhibit-significant-damage.

Pizarro, Judith, Roxane Cohen Silver, and JoAnne Prause. "Physical and Mental Health Costs of Traumatic War Experiences Among Civil War Veterans." February 1, 2006. *JAMA Psychiatry* 63(2): 193–200. http://archpsyc.jamanetwork.com/article.aspx?articleid=209288.

Remsberg, Charles. "Telling the Truth about Police Shootings." *The Police Marksman* 29, no. 2 (November/December 2004). http://www.forcescience.org/articles/tellingthetruth.pdf.

"Report to the Deputy Attorney General on the Events at Waco, Texas, February 28 to April 19, 1993," October 8, 1993 [Redacted Version], https://en.wikisource.org/wiki/Report_to_the_Deputy_Attorney_General_on_the_Events_at_Waco,_Texas.

"Republic of Austria v. Altman 541 U.S. 677 (2004)." Justia Law. October 2003. https://supreme.justia.com/cases/federal/us/541/677/.

Ringgold, Faith. Website. http://www.faithringgold.com/ringgold/default.htm.

Schatz, Bryan. "Meet the 'Monuments Men' Risking Everything to Save Syria's Ancient Treasures from ISIS." Mother Jones. March 6, 2015. http://www.motherjones.com/politics/2015/02/how-isis-cashes-illegal-antiquities-trade.

Slayman, Andrew L. "Geneva Seizure," Archaeology, Online Features, May 3, 1998, updated September 14, 1998. http://archive.archaeology.org/online/features/geneva/.

"Statement by the Press Secretary on the Attack at Tunisia's National Bardo Museum." The White House, Office of the Press Secretary. March 18, 2015. https://www.whitehouse.gov/the-press-office/2015/03/18/statement-press-secretary-attack-tunisia-s-national-bardo-museum.

"Swedish Art Heist." Crime Museum. http://www.crimemuseum.org/crime-library/swedish-art-heist/.

The Thomas Crown Affair. Directed by John McTiernan. Los Angeles, CA: Metro-Goldwyn-Mayer, 1999.

"Trafficking Culture." Trafficking Culture. http://traffickingculture.org/.

UNESCO. "The Fight against the Illicit Trafficking of Cultural Objects: The 1970 Convention: Past and Future," Information Kit; March 15 and 16, 2011, United Nations, http://unesdoc.unesco.org/images/0019/001916/191606E.pdf.

UNESCO. "Introducing UNESCO." http://en.unesco.org/about-us/introducing-unesco.

United Nations. "Convention on the Means of Prohibiting and Preventing the Illicit Import, Export and Transfer of Ownership of Cultural Property 1970," November 14, 1970, United Nations Educational Scientific and Cultural Organization. http://portal.unesco.org/en/ev.php-URL_ID=13039&URL_DO=DO_TOPIC&URL_SECTION=201.html.

United Nations. "Overview." UN News Center. http://www.un.org/en/sections/about-un/overview/index.html.

United Nations Office on Drugs and Crime. https://www.unodc.org/.

U.S. Army. "The Army Values." U.S. Army Homepage. https://www.army.mil/values/.

U.S. Department of Justice. "United States of America v. Glafira Rosales." https://www.justice.gov/archive/usao/nys/pressreleases/July13/RosalesGlafiraIndictmentPR/U.S. v. Glafira Rosales Indictment.pdf.

U.S. Department of State. "Colonization." United States Economy. http://countrystudies.us/united-states/economy-3a.htm.

U.S. Department of State. "How the U.S. Economy Works." http://usa.usembassy.de/etexts/oecon/chap2.htm.

U.S. Immigration and Customs Enforcement (ICE). "Cultural Property, Art and Antiquities Investigations." April 2016. https://www.ice.gov/cultural-art-investigations.

U.S. Immigration and Customs Enforcement (ICE). "History." https://www.ice.gov/history.

U.S. Immigration and Customs Enforcement (ICE). "ICE HSI partners with Ball State University and the David Owsley Museum of Art to recover a hidden idol stolen from India." Cultural Property, Art and Antiquities Investigations. November 17, 2015. https://www.ice.gov/news/releases/ice-hsi-partners-ball-state-university-and-david-owsley-museum-art-recover-hidden-idol.

U.S. Immigration and Customs (ICE). "ICE Returns Dinosaur Skeletons, Eggs to Mongolia." Cultural Property, Art and Antiquities Investigations. April 5, 2016. https://www.ice.gov/news/releases/ice-returns-dinosaur-skeletons-eggs-mongolia.

U.S. Immigration and Customs Enforcement. "Investigating Illegal Movement of People and Goods." Cornerstone. June 10, 2016. https://www.ice.gov/cornerstone.

U.S. Immigration and Customs Enforcement (ICE). "Trade Transparency Unit." https://www.ice.gov/trade-transparency.

U.S. Immigration and Customs Enforcement (ICE). "Who We Are." https://www.ice.gov/about.

Virginia Department of Historic Resources. *Notes on Virginia* 51 (2007). http://dhr.virginia.gov/pdf_files/NOTES2007FINALPDF2.pdf.

Von Beyme, Klaus. On "Political Culture, Cultural Policy, Art and Politics." In *Springer-Briefs on Pioneers in Science and Practice*, Volume 15, edited by Hans Günter Brauch, chapters 2, 19–33, and 7, pp. 101–116. Cham: Springer, 2014.

Wittman, Robert K. "Cold Case." In *Priceless: How I Went Undercover to Rescue the World's Stolen Treasures*, 249–55. New York: Crown, 2010.

INDEX

ABOUT THE AUTHORS

Colleen Margaret Clarke, PhD, is professor and former director of the Law Enforcement Program at Minnesota State University, Mankato. She contributed to *The Encyclopedia of Street Crime in America* and *The Encyclopedia of Criminology and Criminal Justice*. In addition, she has written many articles on law enforcement and policing, including such publications as the *National Social Science Journal*, *International Journal of Police Strategies and Management*, and *Law Enforcement Executive FORUM*. She was formerly a police officer with the Thunder Bay Police Department before transferring to the business and ventures division; currently, she teaches law enforcement and criminal justice.

Eli J. Szydlo received his background in law enforcement from his undergraduate studies at Minnesota State University, Mankato, and from more than three years of volunteering as a reserve sergeant for the Northfield Police Department. He developed a background in the arts from three semesters at the Kansas City Art Institute, prior to completing his degree at Minnesota State University, Mankato. He first encountered the field of art crimes at the Perpich Center for Arts Education, a Minnesota Arts education high school.